IMPRESSIONS of

AUSTRALIA

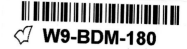

Produced by AA Publishing

© Automobile Association Developments Limited 2008

All rights reserved. No part of this publication may be reproduced, stored in
a retrieval system, or transmitted in any form or by any means – electronic,
photocopying, recording or otherwise – unless the written permission of the
publishers has been obtained beforehand.

Published by AA Publishing (a trading name of Automobile Association
Developments Limited, whose registered office is Fanum House, Basing View,
Basingstoke, Hampshire RG21 4EA; registered number 1878835)

ISBN: 978-0-7495-5857-4

A03676

A CIP catalogue record for this book is available from the British Library.

The contents of this book are believed correct at the time of printing. Nevertheless,
the publishers cannot be held responsible for any errors, omissions or for changes in
the details given in this book or for the consequences of any reliance on the
information provided by the same. This does not affect your statutory rights.

Colour reproduction by KDP, Kingsclere
Printed and bound in Thailand by Sirivatana Interprint Public Co Ltd

Opposite: Viewpoint at Wentworth Falls in the Blue Mountains, New South Wales.
The Blue Mountains derive their name from the blue haze produced by the oil released from the eucalyptus trees there.

IMPRESSIONS *of*
AUSTRALIA

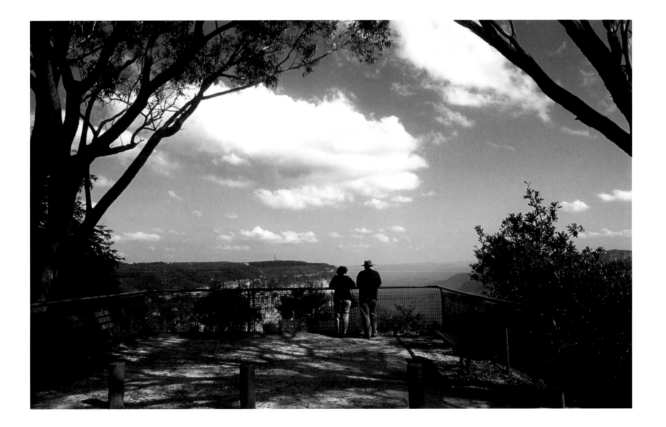

Picture Acknowledgements

The Automobile Association would like to thank the following photographers, companies and picture libraries for their assistance in the preparation of this book.

Abbreviations for the picture credits are as follows: (t) top; (b) bottom; (l) left; (r) right; (AA) AA World Travel Library.

Front Cover AA/M Langford; Back Cover AA/A Baker; Back Cover inset AA/A Belcher;

3 AA/P Kenward; 5 AA/M Moody; 7 AA/A Baker; 8 AA/A Belcher; 9 AA/B Bachman; 10 AA/B Bachman; 11 AA/A Belcher; 12 AA/P Kenward; 13 AA/S Watkins; 14 AA/M Langford; 15 AA/S Day; 16 AA/A Baker; 17 AA/A Belcher; 18 AA/A Belcher; 19 AA/M Langford; 20 AA/S Day; 21 AA/B Bachman; 22 AA/S Richmond; 23 AA/A Belcher; 24 AA/A Baker; 25 AA/A Baker; 26 AA/S Day; 27 Australian Tourist Commission; 28 AA/A Baker; 29 AA/S Day; 30 AA/S Watkins; 31 AA/S Day; 32 AA/S Day; 33 © World Pictures/Alamy; 34 AA/S Day; 35 AA/A Baker; 36 AA/B Bachman; 37 AA/S Richmond; 38 AA/P Kenward; 39 AA/M Langford; 40 AA/S Day; 41 AA/S Day; 42 AA/A Belcher; 43 AA/B Bachman; 44 AA/M Langford; 45 AA/L K Stow; 46 AA/B Bachman; 47 AA/S Watkins; 48 © Jon Arnold Images Ltd/Alamy; 49 AA/A Belcher; 50 AA/A Belcher; 51 AA/S Day; 52 © Mira/Alamy; 53 AA/P Kenward; 54 AA/A Baker; 55 AA/S Day; 56 AA/P Kenward; 57 AA/M Cawood; 58 AA/M Langford; 59 AA/A Belcher; 60 AA/A Baker; 61 © John White Photos/Alamy; 62 AA/S Richmond; 63 Australian Tourist Commission; 64 AA/S Watkins; 65 AA/B Bachman; 66 AA/B Bachman; 67 AA/M Langford; 68 AA/A Belcher; 69 AA/S Richmond; 70 AA/S Watkins; 71 AA/M Langford; 72 AA/A Baker; 73 AA/M Langford; 74 AA/M Langford; 75 AA/B Bachman; 76 AA/B Bachman; 77 AA/A Baker; 78 Australian Tourist Commission; 79 AA/A Belcher; 80 AA/A Belcher; 81 AA/A Belcher; 82 AA/M Langford; 83 AA/A Belcher; 84 AA/S Day; 85 AA/B Bachman; 86 AA/M Langford; 87 AA/B Bachman; 88 AA/A Belcher; 89 AA/B Bachman; 90 AA/M Langford; 91 AA/B Bachman; 92 AA/A Baker; 93 AA/S Day; 94 AA/S Day; 95 AA/B Bachman.

Every effort has been made to trace the copyright holders, and we apologise in advance for any accidental errors. We would be happy to apply the corrections in the following edition of this publication.

Opposite: Three endearing koalas are at home in the branches of a eucalyptus tree at Lone Pine Koala Sanctuary, Brisbane. One has a 'joey' in her pouch where it will spend up to seven months growing.

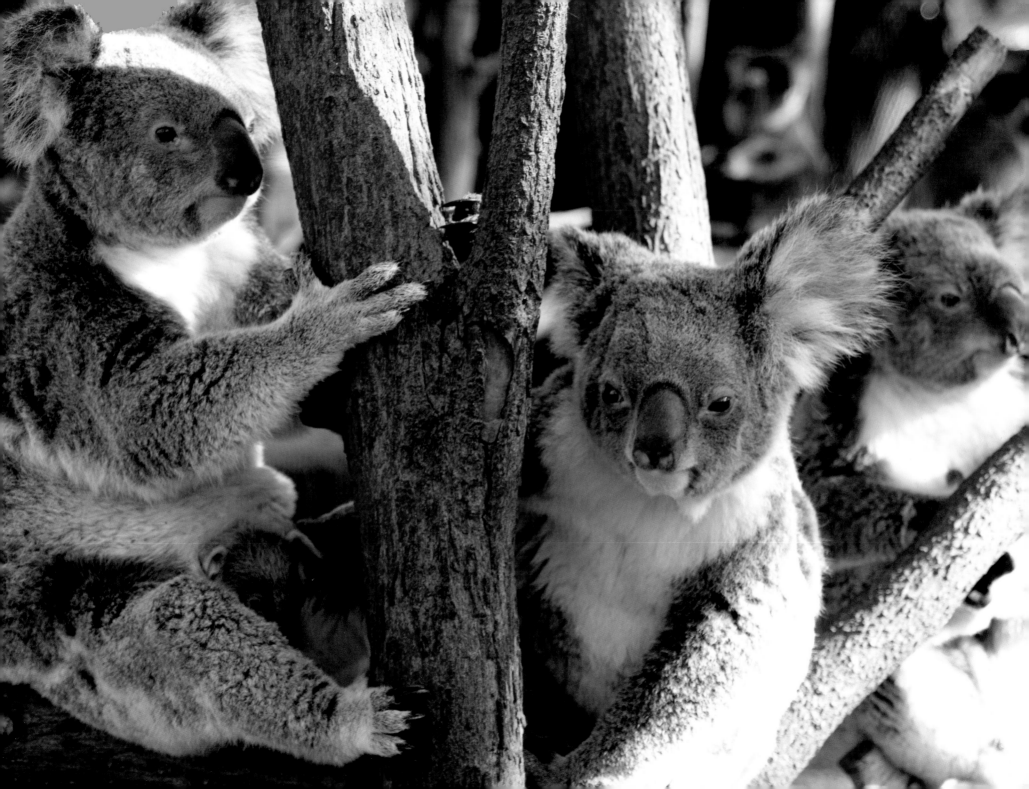

INTRODUCTION

More than simply a country, Australia is a continent, remarkable not only for its sheer size – it's the earth's largest island covering a total area of 2,967,900 square miles (7,659,861 square kilometres) – but also for its contrasting scenery. Here the land gives occasion to vast deserts, endless expanses of bush, lush rainforests, spectacular beaches, fertile grazing land and snowy peaks on mountain ranges. Travellers from around the globe will not be disappointed when they discover the magic of its suprising landscapes, the cultural variety of its cities and the relaxed temperament of the Australian people, who are renowned for their outgoing nature and enthusiasm for outdoor life.

The first European sighting of Australia was made by a Dutchman called Willem Janszoon aboard the ship, *Duyfken*, in 1606. However until 1788, when the First Fleet arrived in Sydney Cove to establish the first settlement to become a penal colony, Australia was home only to Aboriginal people and its indigenous animals. This settlement followed the earlier 1770 landing in Botany Bay by Captain Cook to claim New South Wales for Britain.

During the 18th and 19th centuries, further convicts were deported to its shores and an age of exploration began. European settlers arrived and gold was discovered, leading to the famous gold rushes of 1851–1861. However by 1868 convict transportation had ended and in 1901 the Commonwealth of Australia was created forming a federation of the states of New South Wales, Victoria, Tasmania, Queensland, Western Australia and South Australia.

Once land-linked to India, Africa and Antarctica, Australia is the smallest, flattest and lowest continent, its lowest point being Lake Eyre in South Australia at 50 feet (15m) below sea level. It is also the driest inhabited continent and it has a population close to 20 million people.

New South Wales is Australia's oldest state and an area of outstanding beauty with places like the Snowy Mountains, Blue Mountains National Park and Bondi Beach creating major attractions. The state's captivating capital, Sydney, is a cosmopolitan city with sights like the Opera House, Harbour and Royal Botanic Gardens, making it an essential stop for any traveller.

Queensland boasts a tropical climate and sparkling white beaches that are the envy of the world, including those of the Great Barrier Reef, which is close to its shores. Here the sophistication of the Gold Coast and Resort Islands contrast beautifully with the vibrance of its capital city, Brisbane.

A trip to Australia would not be complete without visiting Melbourne, the state capital of Victoria. Its parks, gardens, trams and traditional architecture blend with contemporary buildings in what is a thriving centre for shopping, art, culture and business.

Cities also of note are Perth, the beautiful state capital city of Western Australia with its Mediterranean climate; Adelaide, the sophisticated capital of South Australia and Canberra, the national capital of Australia and the country's largest inland city, situated south of Sydney.

This collection of images takes you on a photographic journey which captures the immense variety and immeasurable beauty of this unique country.

Opposite: The red sandstone rock formation of Uluru in the Kata Tjuta National Park. It is the world's largest monolith and a sacred site for Aboriginal people.

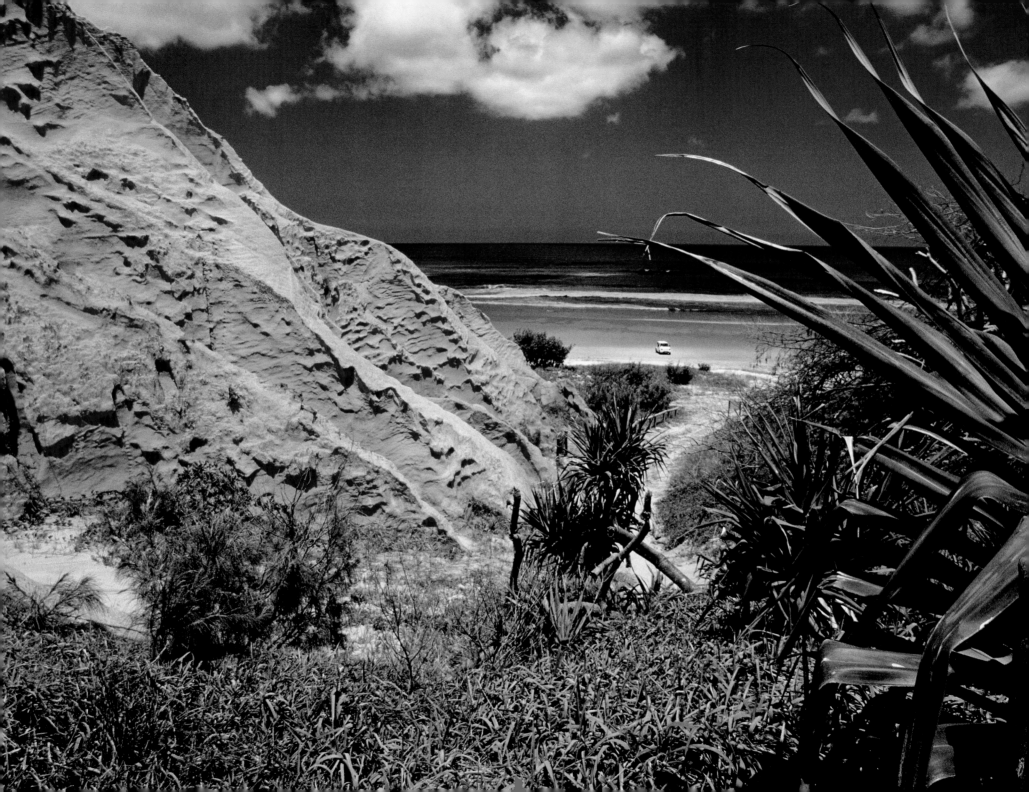

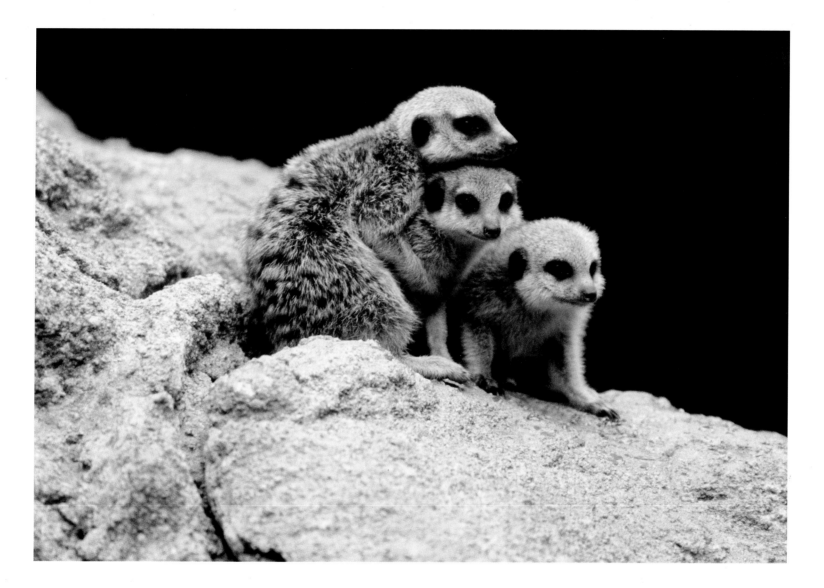

Three meerkats at the Royal Melbourne Zoo in Parkville where more than 320 species of wildlife can be viewed.
Opposite: Red Canyon on Fraser Island. Fraser Island, the biggest sand island in the world, is renowned for its breathtaking beauty.

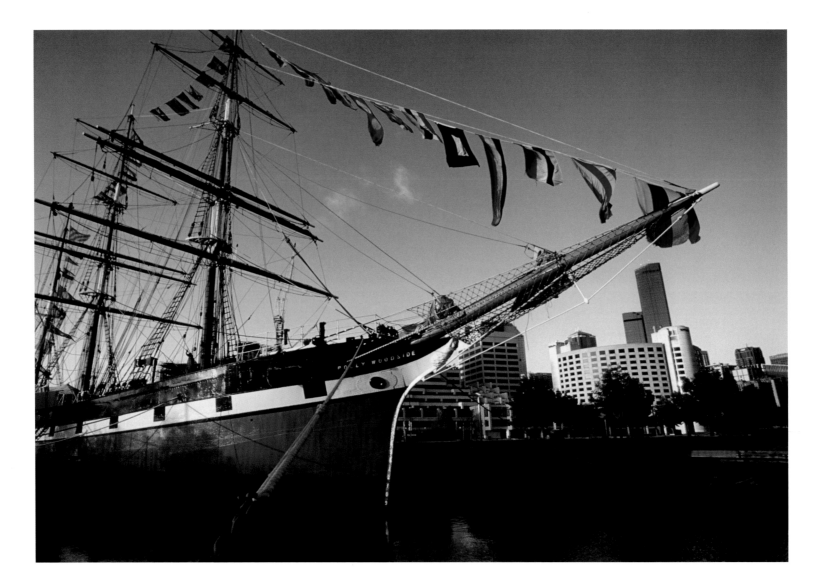

The Polly Woodside, a restored nineteenth century sailing vessel, is also a Maritime Museum.
It is located in front of the Melbourne Exhibition Centre, in Southbank, on the Yarra River

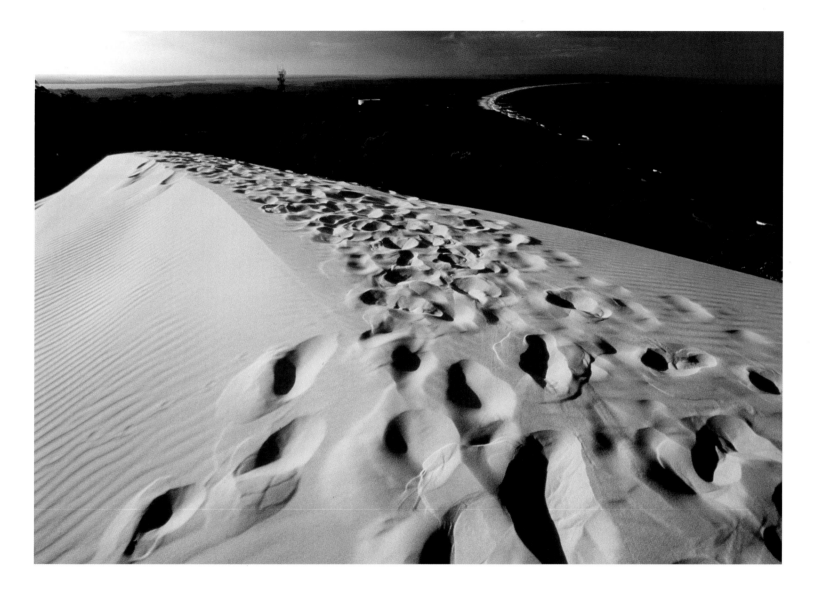

Sand dunes at Noosa Heads National Park on the sunshine coast, north of Brisbane, where some of Australia's best surfing beaches can be found. The park is a sanctuary for rainforests, scrubland, beaches and coves. Its entrance is found close to Noosa town centre.

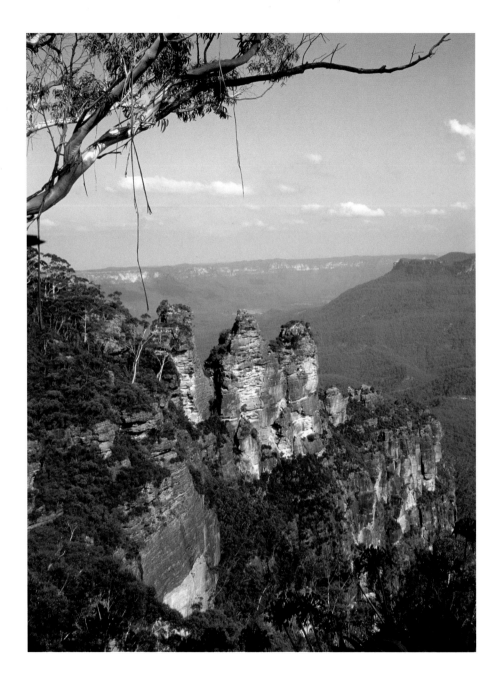

The legendary Three Sisters in the Blue Mountains, New South Wales. Echo Point looks out over the famous rock formation and is close to the historic town of Katoomba.

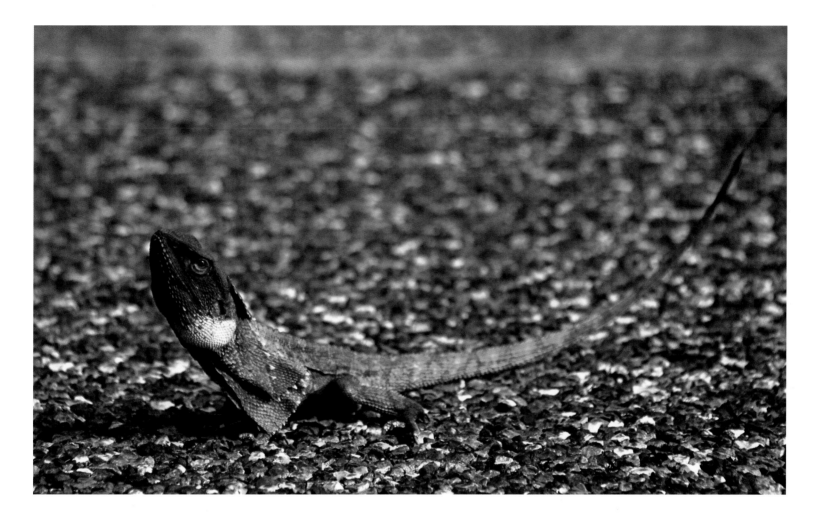

A frill-necked lizard, which is partial to hot climates, basks on a road in northern Australia, where its numbers are prolific.

The Rocks, the site of Australia's first European settlement in 1788, as seen from the Cahill Expressway, where
many of its streets, houses and shops were demolished to make way for the road.
Opposite: Sydney Harbour Bridge, Australia's most famous landmark, bathed in an orange sunset as a yacht sails by.
The steel arch bridge carries motor, rail and pedestrian traffic across Sydney Harbour. This view is from Bradley Head.

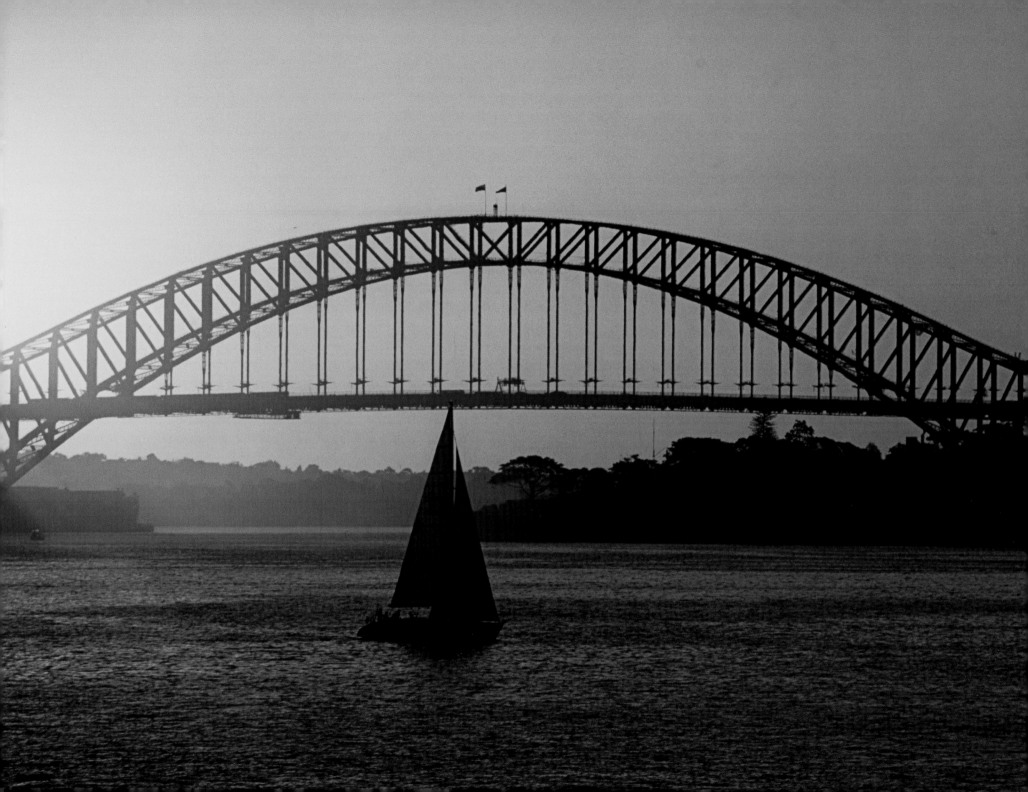

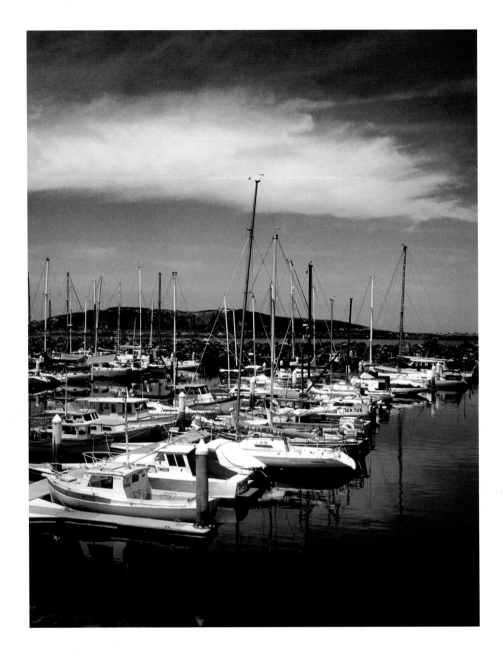

*Pleasure craft moored at Coffs Harbour, a popular destination for water sports
and whale watching, which is located between Sydney and Brisbane.*

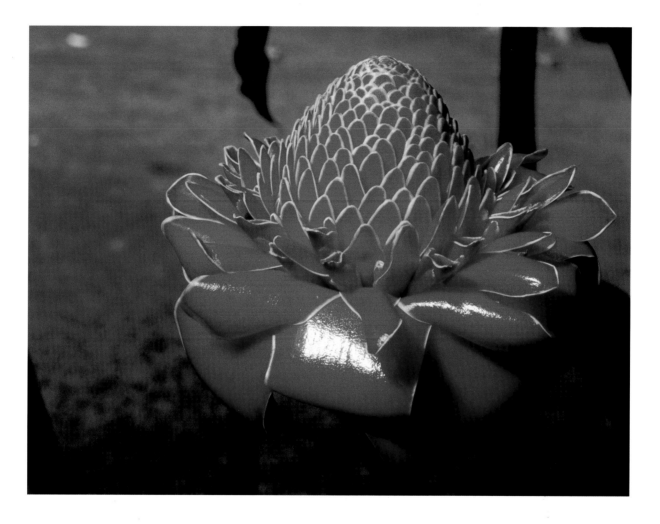

The exotic Zingiberaceae Etlingera Elatior, commonly known as the Torch Ginger flower, pictured at Flecker Botanical Gardens near Cairns City.

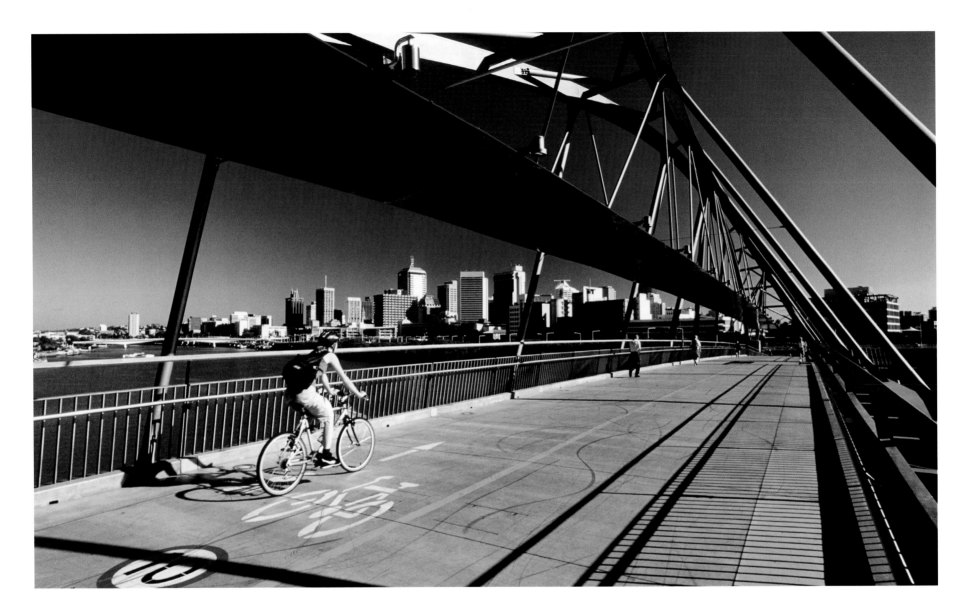

The Goodwill Bridge, a pedestrian and cyclist bridge, spanning the Brisbane River to connect the South Bank Parklands with the Central Business District of Brisbane on the northside.

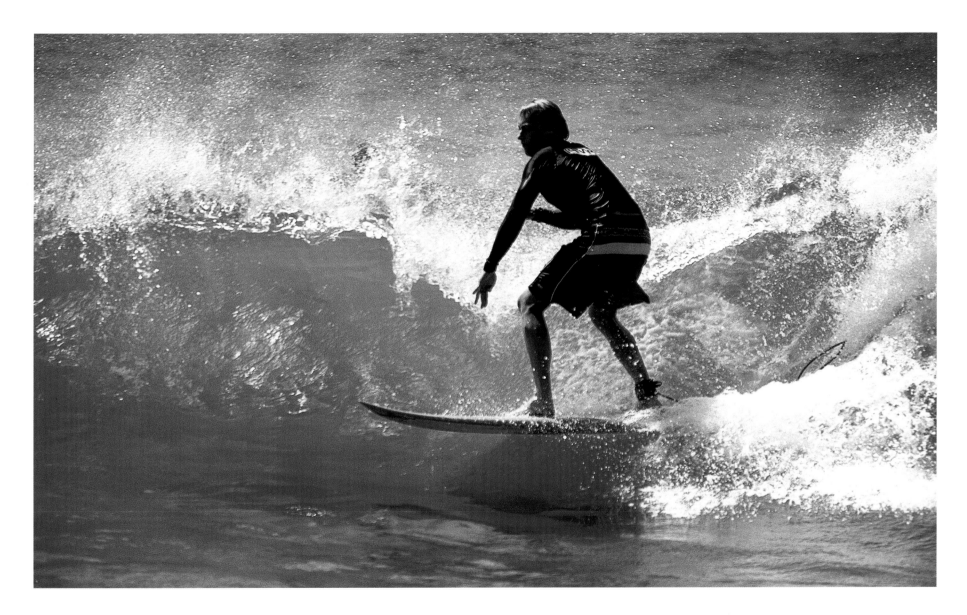

A surfer on Bondi Beach, the world famous suburb and beachside resort on the outskirts of Sydney.

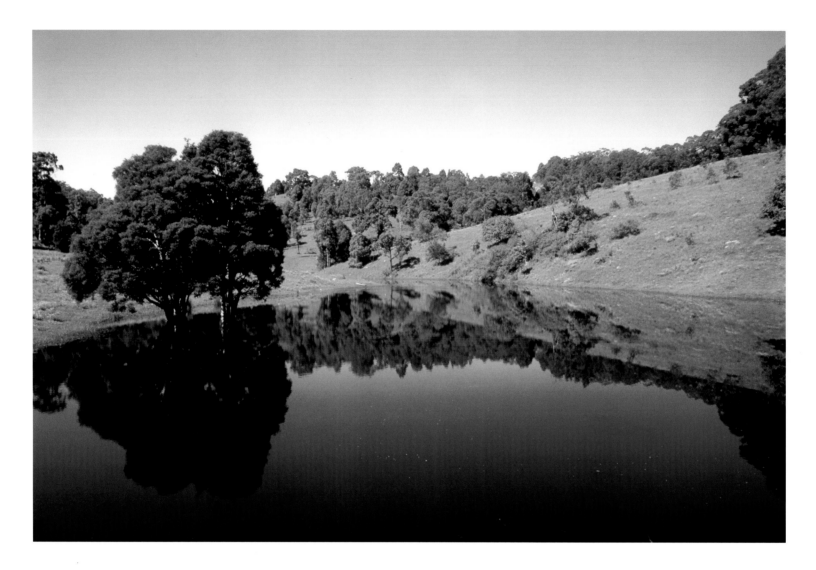

Trees reflected in the peaceful waters of a lake by Mount Pokolbin in the Hunter Valley, Australia's premier wine region.

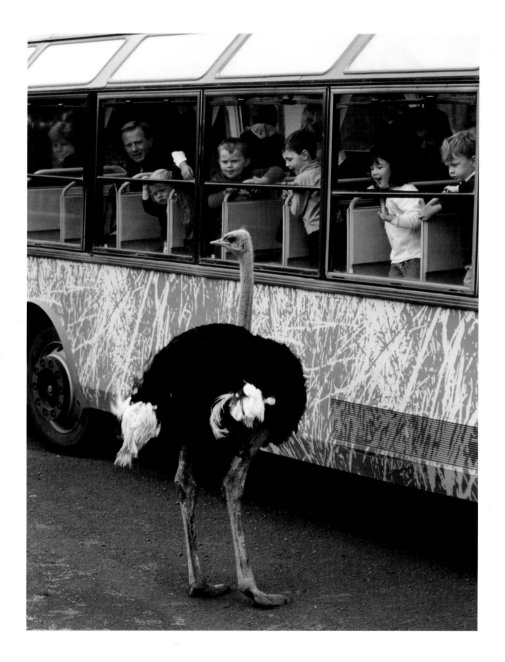

An ostrich spots some tourists on a safari tour of Werribee Open Range Zoo, south west of Melbourne.

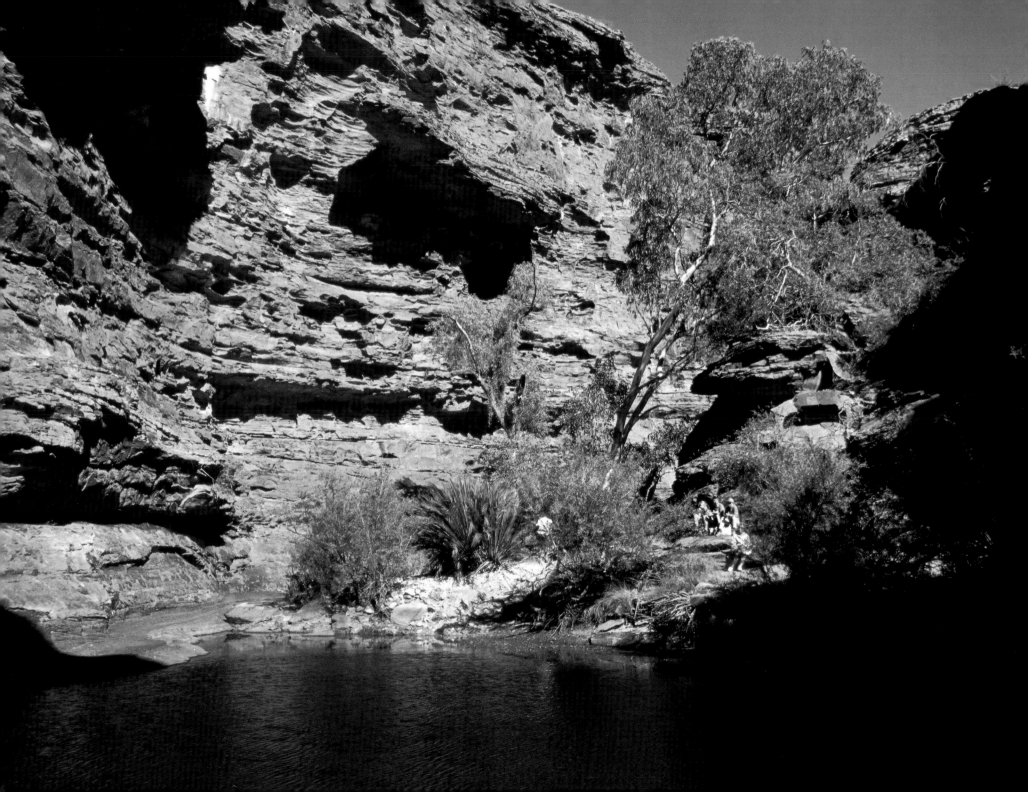

Detail of a decorative wooden butterfly demonstrates the beautiful craft of marquetry.
Opposite: Hikers take a rest at the waters edge of the Garden of Eden, a permanent waterhole in Kings Canyon and a popular destination
for walkers in Watarrka National Park in the Northern Territory.

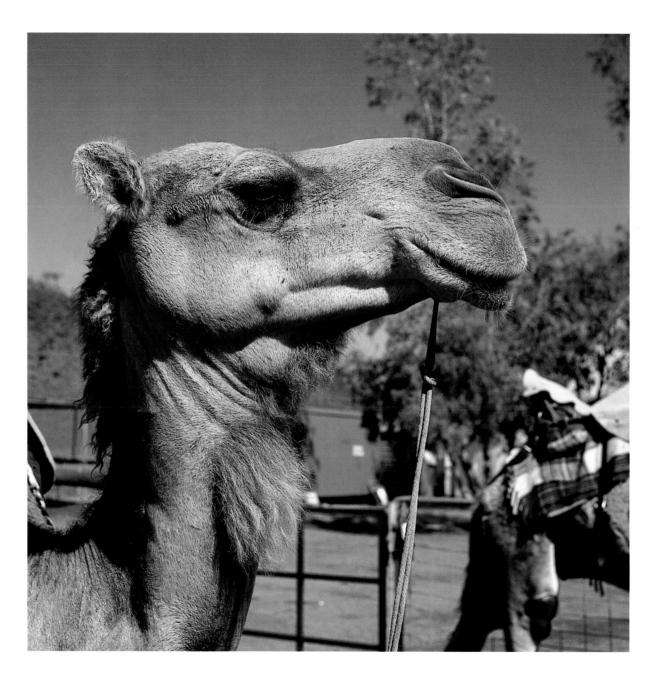

Camels can be ridden at the Frontier Camel Farm and museum located on the Ross Highway,
south of Alice Springs in the Northern Territory.

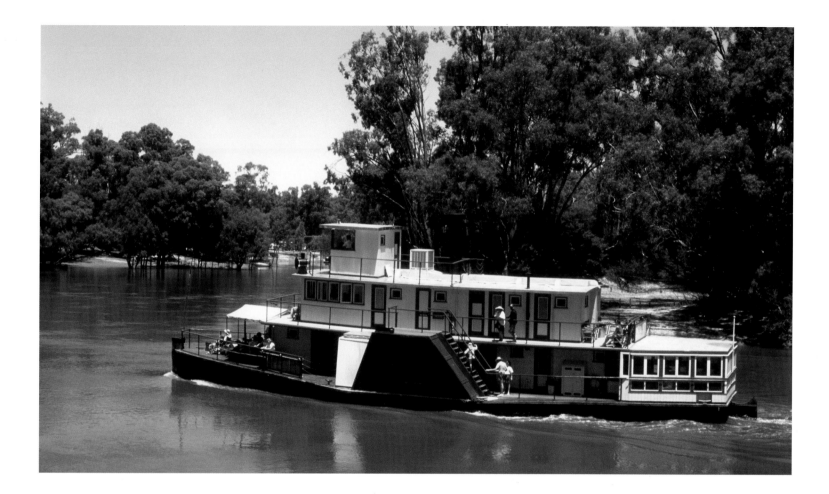

A restored paddle steamer brings nostalgic memories to the Murray River, where they were regularly used for passenger travel, cargo and pleasure trips. The Murray stretches from the Snowy Mountains in the south east of New South Wales to Southern Australia.

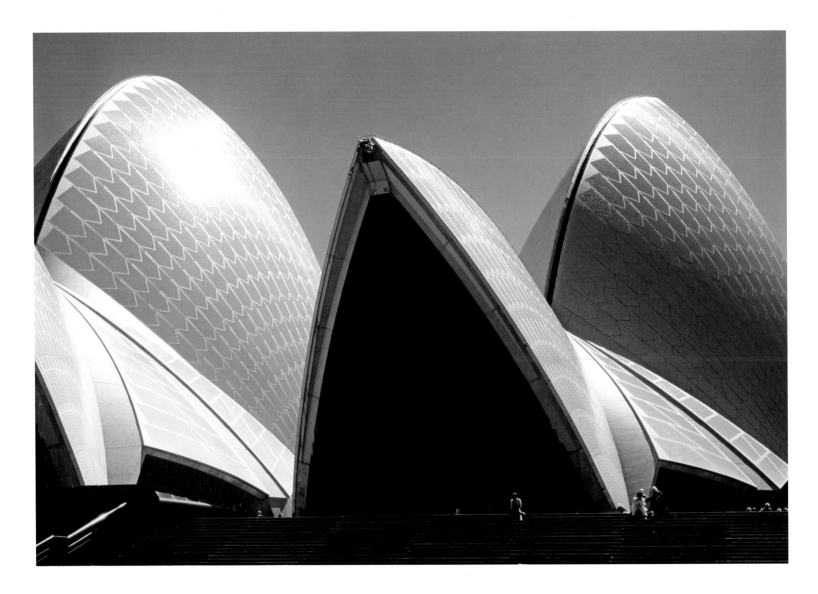

The curved forms of the Sydney Opera House create a landmark in harmony with its waterside setting.
Designed by Danish architect Jørn Utzon, it has been heralded as one of the great architectural works of the 20th century.

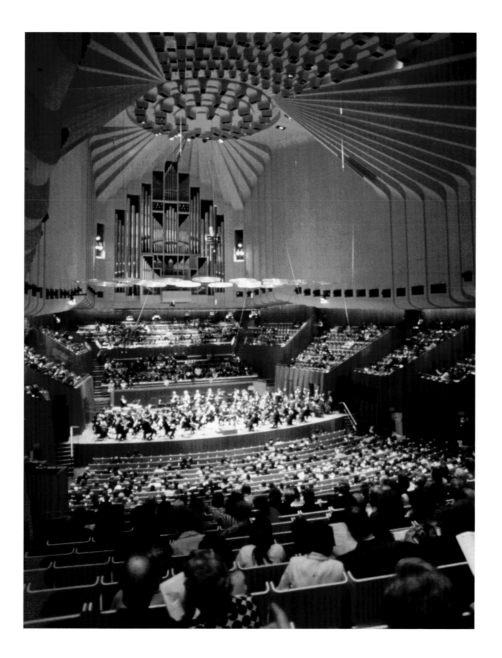

The interior of the Concert Hall, Sydney Opera House.
Its high vaulted ceiling and interior finish of brush box and white birch
is designed primarily to help enhance performances.

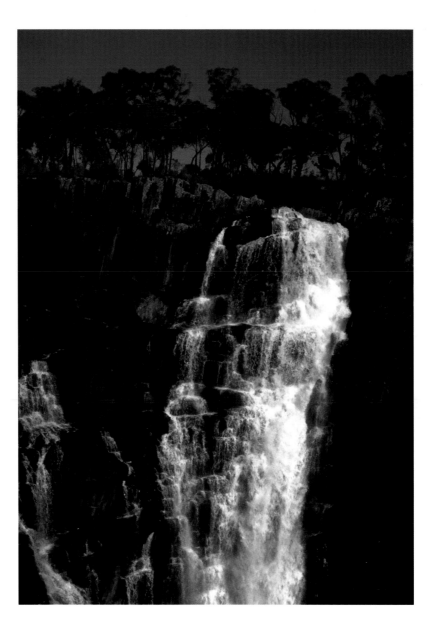

Apsley Falls, east of Walcha, at the southern end of Oxley Wild Rivers
National Park in New England, northern New South Wales.

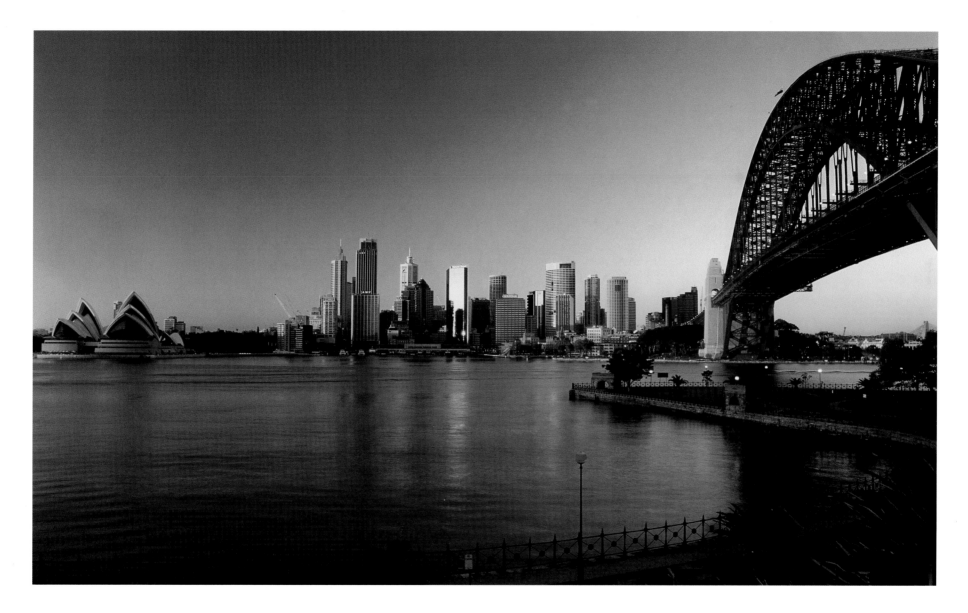

Sydney's city skyline as dawn breaks over the high rise buildings of the Central Business District.
Sydney Harbour Bridge is seen stretching across the river from Milsons Point.

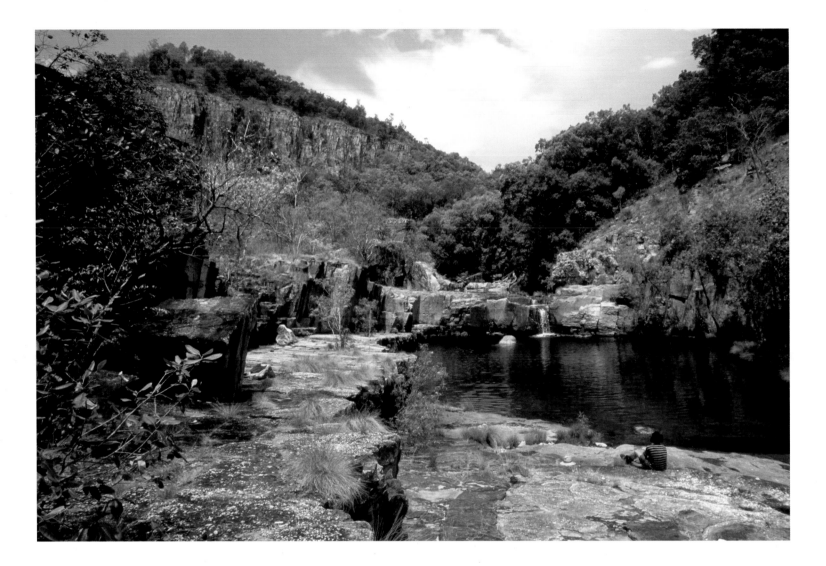

Graveside Gorge in Kakadu National Park in the Northern Territory is known for its beautiful waters and craggy rock faces.
The Aboriginal traditional owners of the park descend from the original clans of the Kakadu.
Opposite: Flower beds and palm trees in the foreground of the Tropical Centre's glass pyramid, which houses exotic plants,
at Sydney's inner-city oasis, the Royal Botanic Gardens.

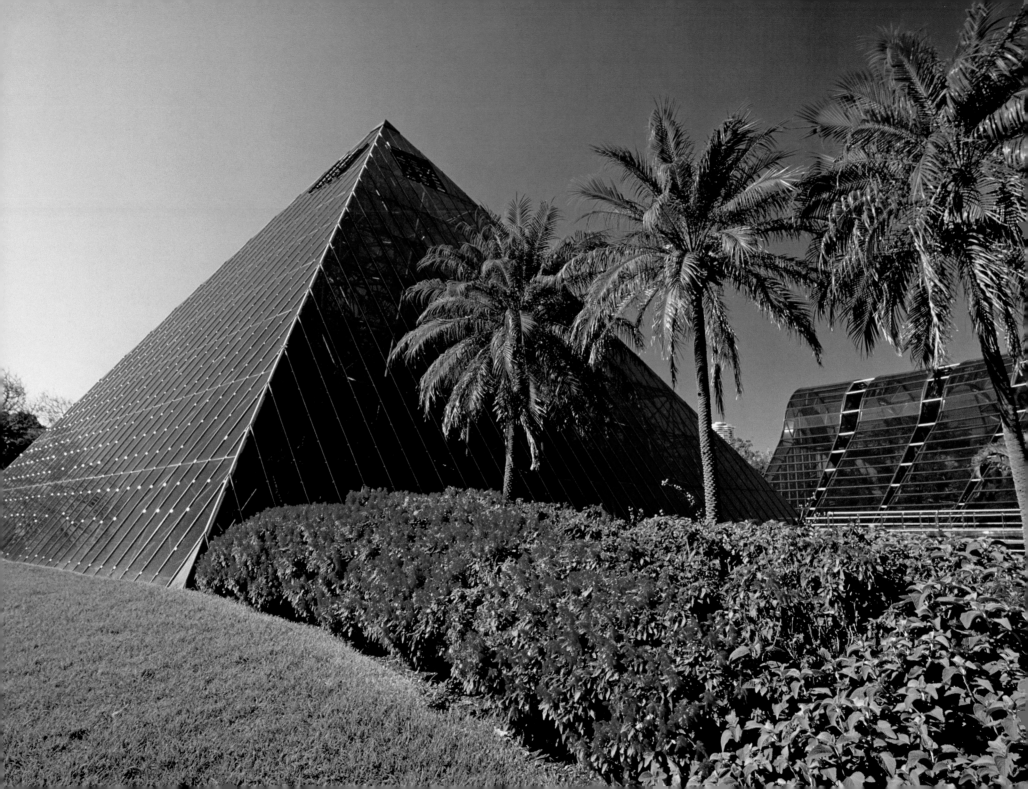

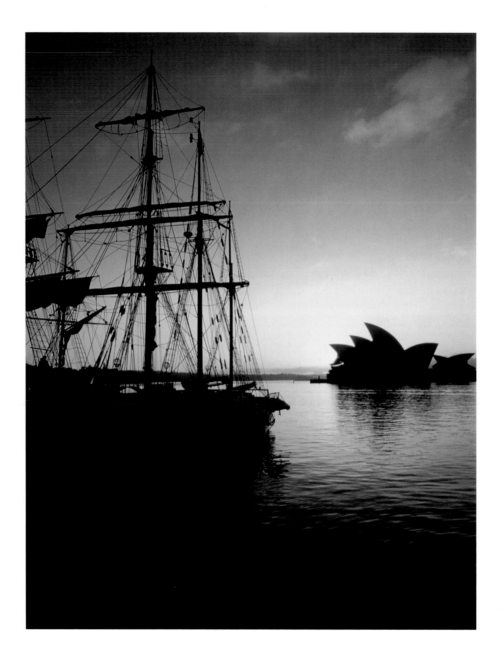

*Sydney Harbour as the dawning sun illuminates the water with the dramatic roofline
of the Opera House silhouetted in the distance. This view is from Campbell's Cove
with the tall ship, 'Svanen', in the foreground.*

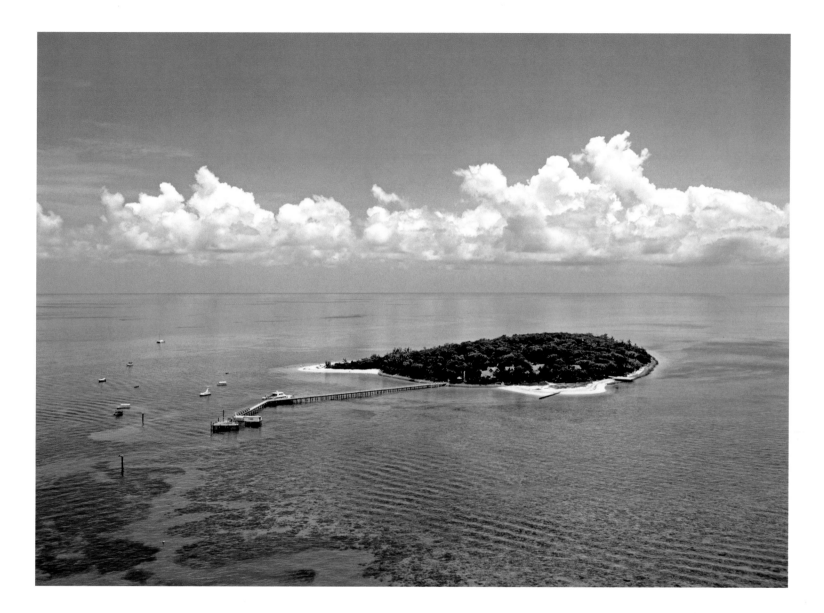

Green Island is one of only three resort islands set amongst the clear waters of the Great Barrier Reef itself. It is home to the reef's long-established Underwater Observatory where the wonders of the coral can be viewed from three fathoms deep.

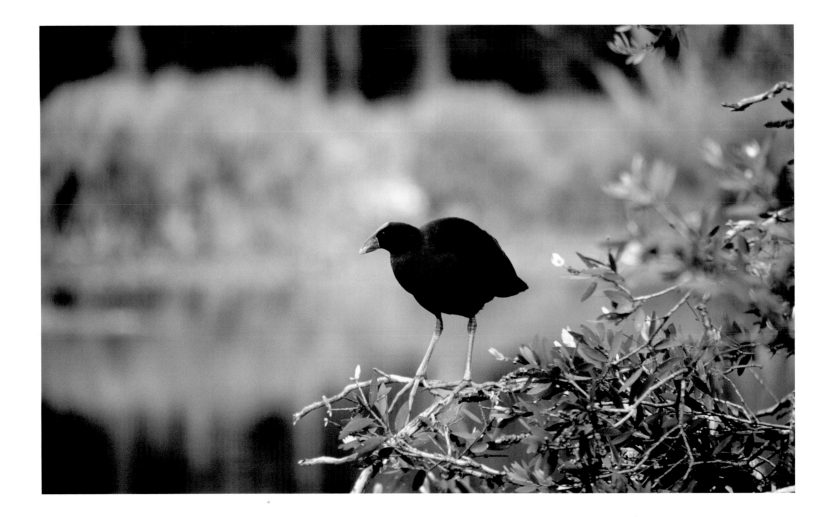

A Purple Gallinule, also known as a Swamp Hen or Pukeko (Porphyrio Melanotos),
standing on a branch of a bush in Centennial Park, Sydney.

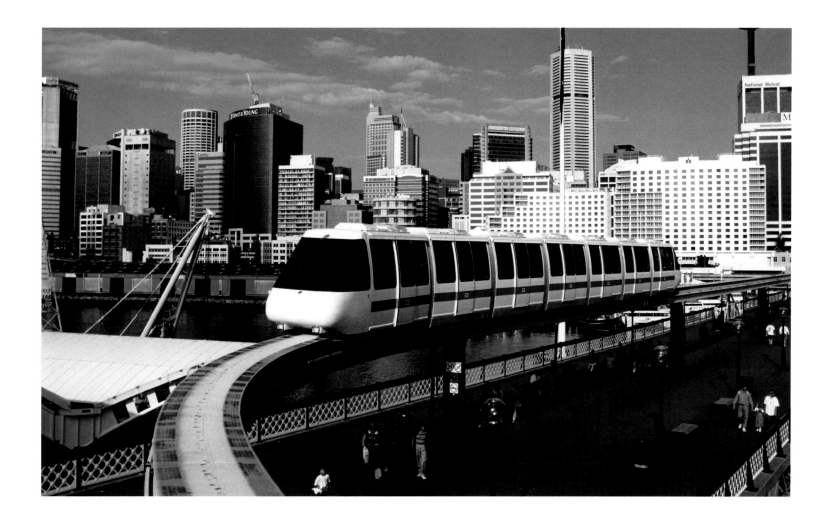

The monorail circling Darling Harbour before returning to the city centre of Sydney.
Its elevated position provides a picturesque view of the harbour.

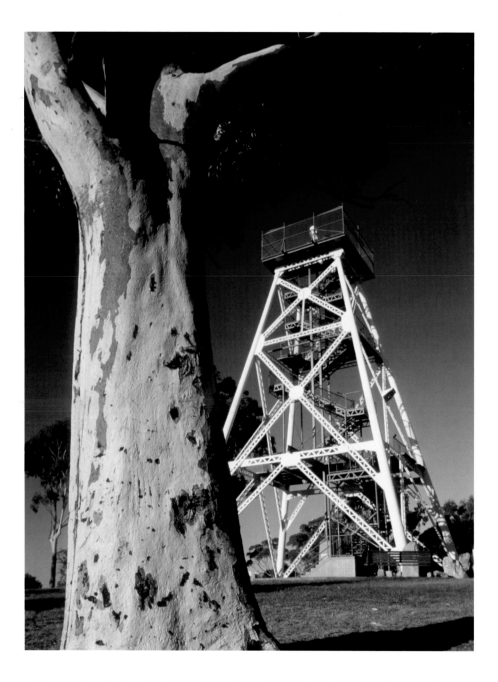

A poppet head of an old gold mine at Camp Hill, Bendigo. The Bendigo Creek gave its name to the goldfield (formerly Sandhurst) and subsequent city in central Victoria.

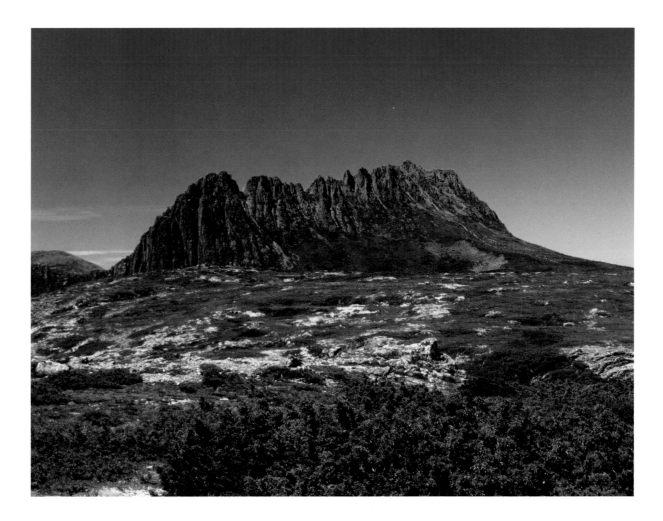

Barn Bluff in Cradle Mountain-Lake St. Clair National Park, as approached from the Tasmanian Overland Track.

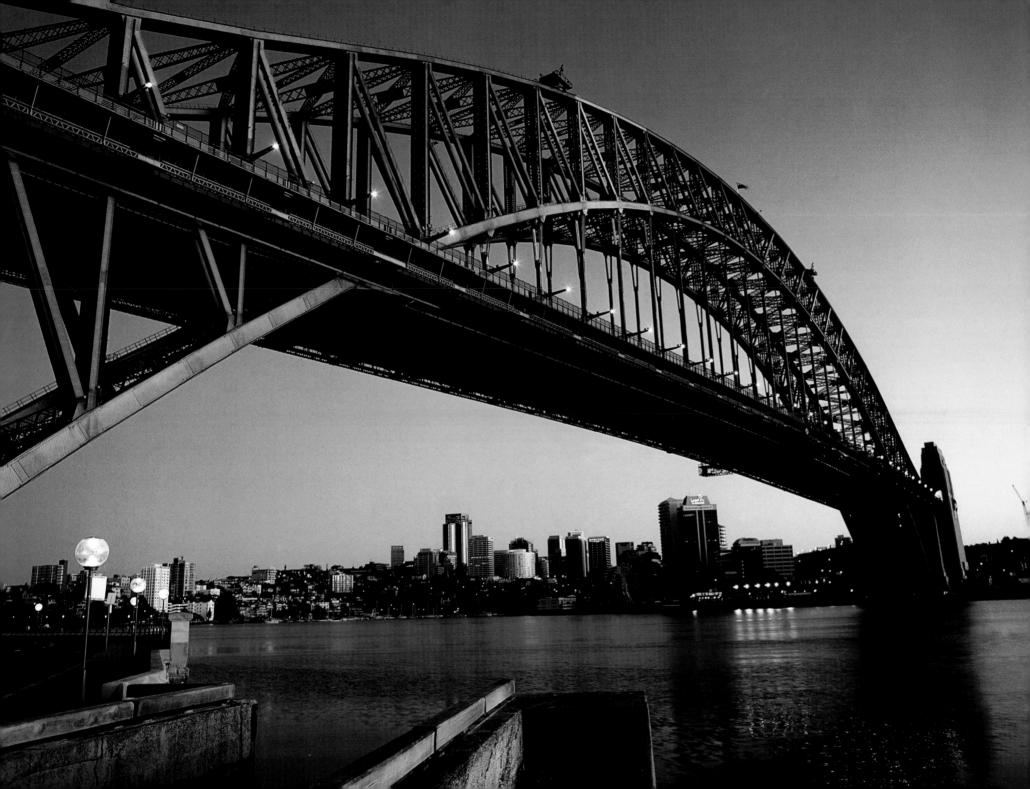

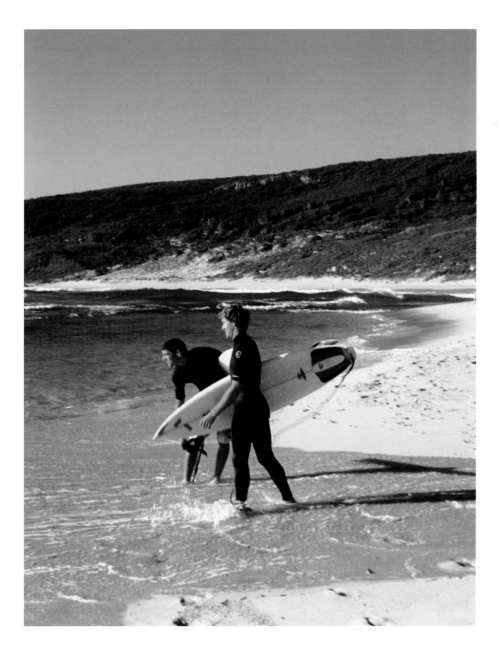

Surfing at Yallingup Beach in Western Australia.
Opposite: Looking up at Sydney Harbour Bridge (completed in 1932)
towards Lavender Bay, Sydney's harbourside suburb.

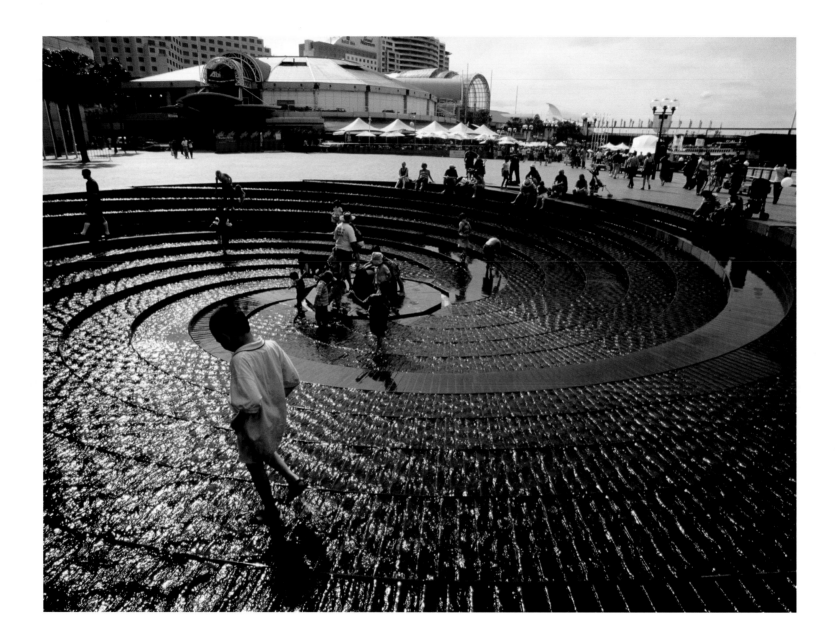

Families play in the swirling water feature known as the 'Tidal Cascade' fountain in Darling Harbour, Sydney.

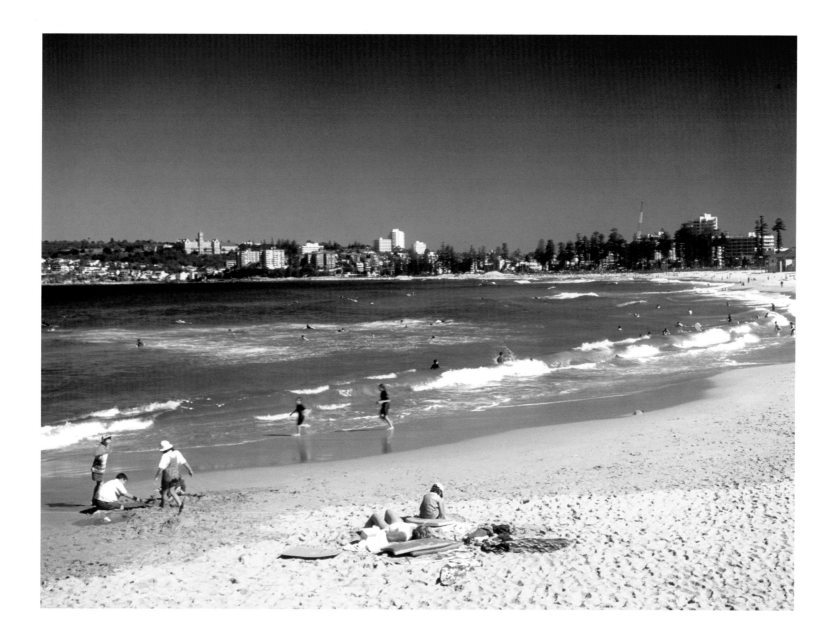

People enjoying the sun on the sweeping golden sands of Manly Beach. Manly Beach is one of Sydney's northern beaches and a popular destination for both locals and tourists alike.

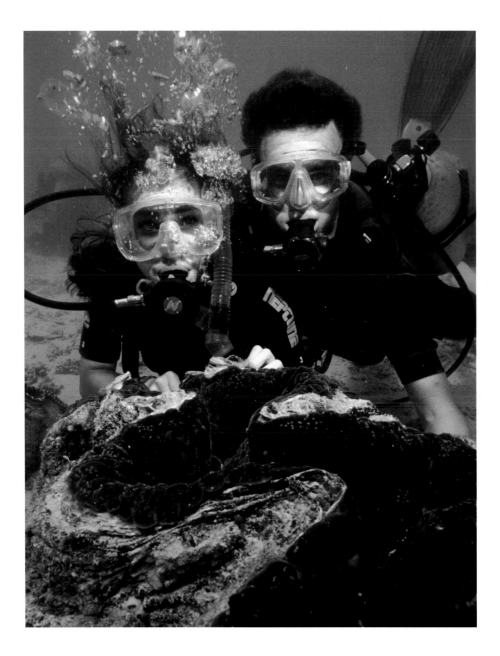

A couple scuba diving in the magnificent coral beds of the Great Barrier Reef.

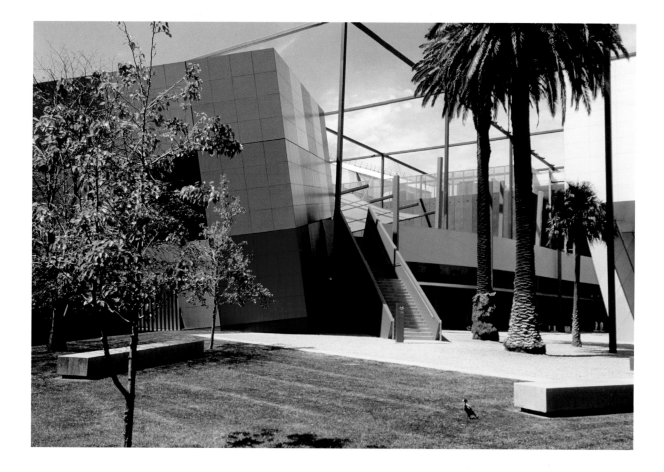

The Children's Garden situated next to the Melbourne Museum in the historic
Carlton Gardens of Melbourne city centre.

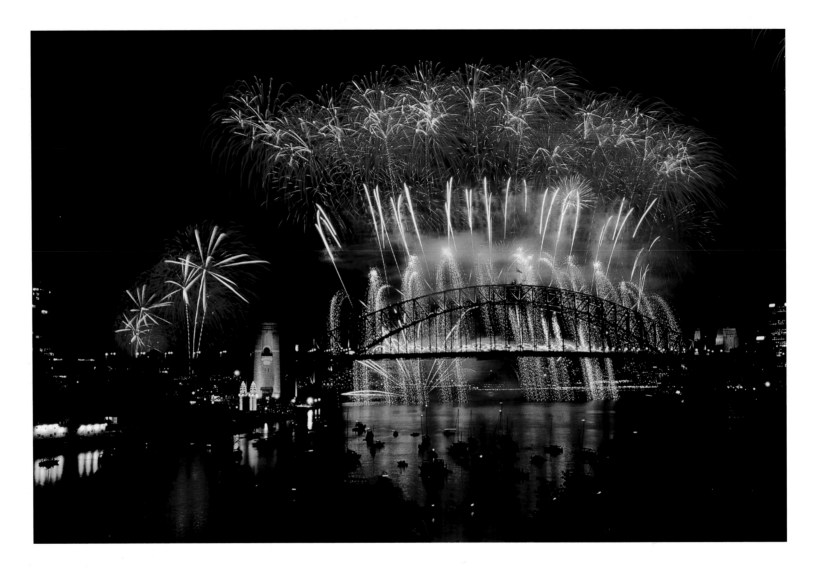

A New Year's fireworks display lights up Sydney Harbour and Sydney Harbour Bridge.
Opposite: A boat travels through the water at the Great Barrier Reef, the world's largest coral reef system,
which comprises nearly 3,000 individual reefs.

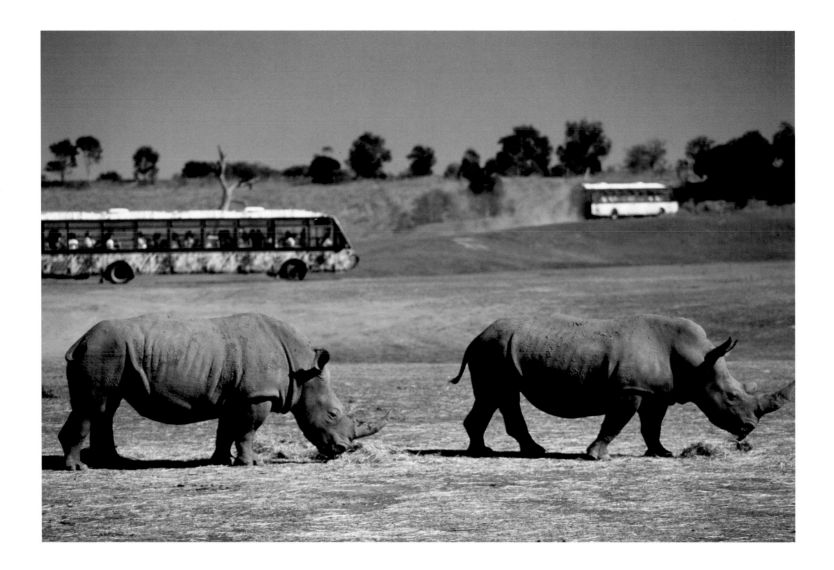

White Rhinos at Werribee Open Range Zoo, with tour buses at a safe distance in the background.
The Southern White is the largest of the five species of rhinoceros.

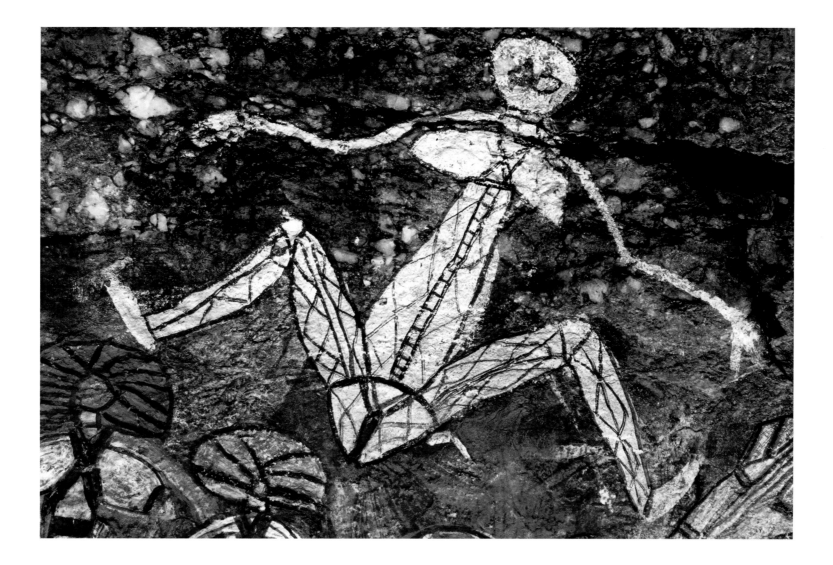

Aboriginal rock art at Nourlangie Rock in Kakadu National Park,
Northern Territory. The paintings depict the historical stories of the Aboriginal clans.

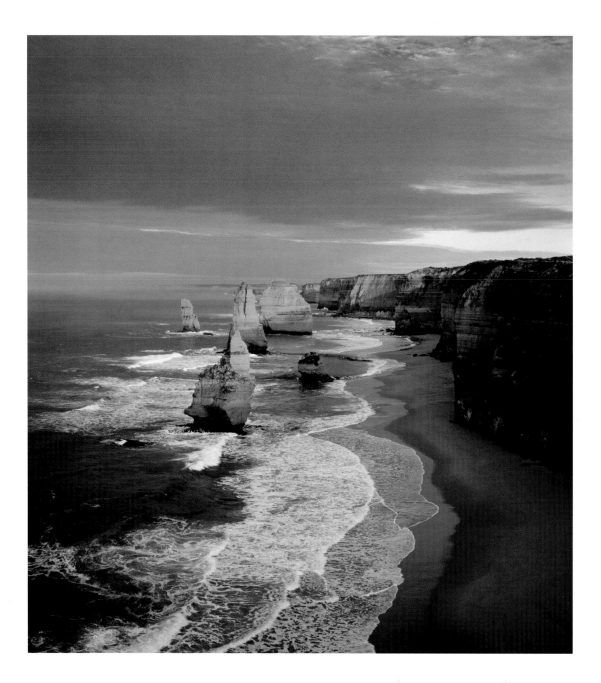

High cliffs, golden sands and crystal blue sea with the majestic Twelve Apostles standing offshore.
These giant limestone formations are in the Port Campbell National Park, Great Ocean Road, Victoria.

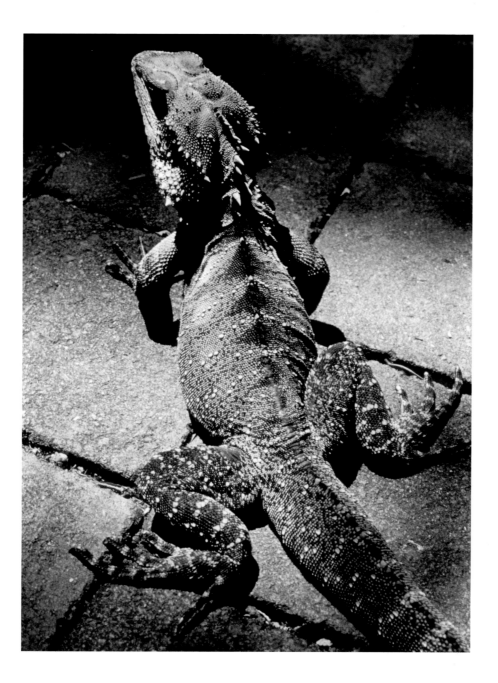

A lizard at Currumbin Wildlife Sanctuary on the Gold Coast in Queensland, where hundreds of native Australian animals are displayed in their natural environment.

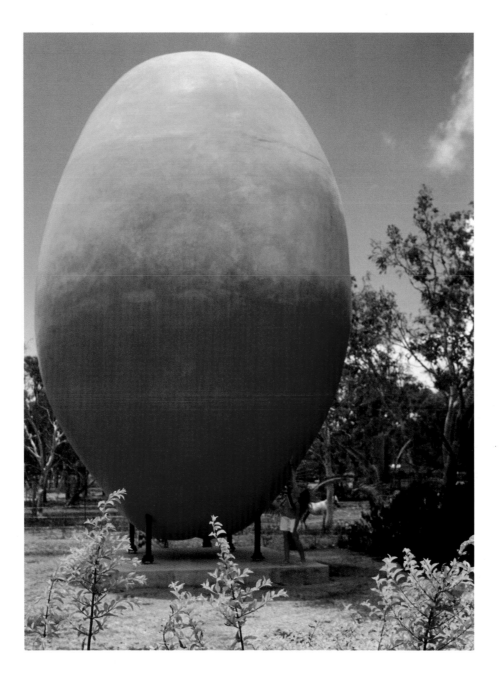

The Big Mango is a giant sculpture in the town of Bowen,
located between Mackay and Townsville in Queensland.

The lush green Hunter Valley in New South Wales is famous for its wine production.

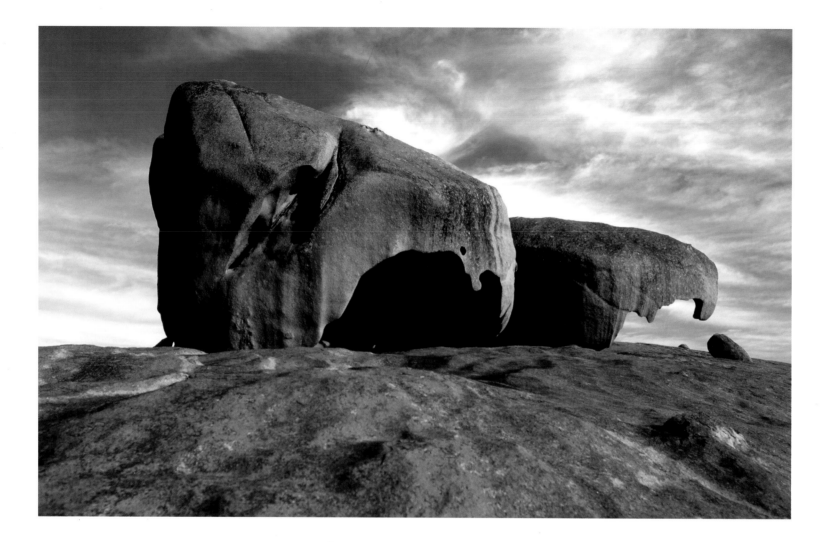

Rocks in the unspoilt terrain of Kangaroo Island in South Australia.

Opposite: The Sydney Opera House, which is evocative of a ship in full sail, is dramatically silhouetted against a golden sunset.

Completed in 1973, it is one of the most famous performing arts venues in the world.

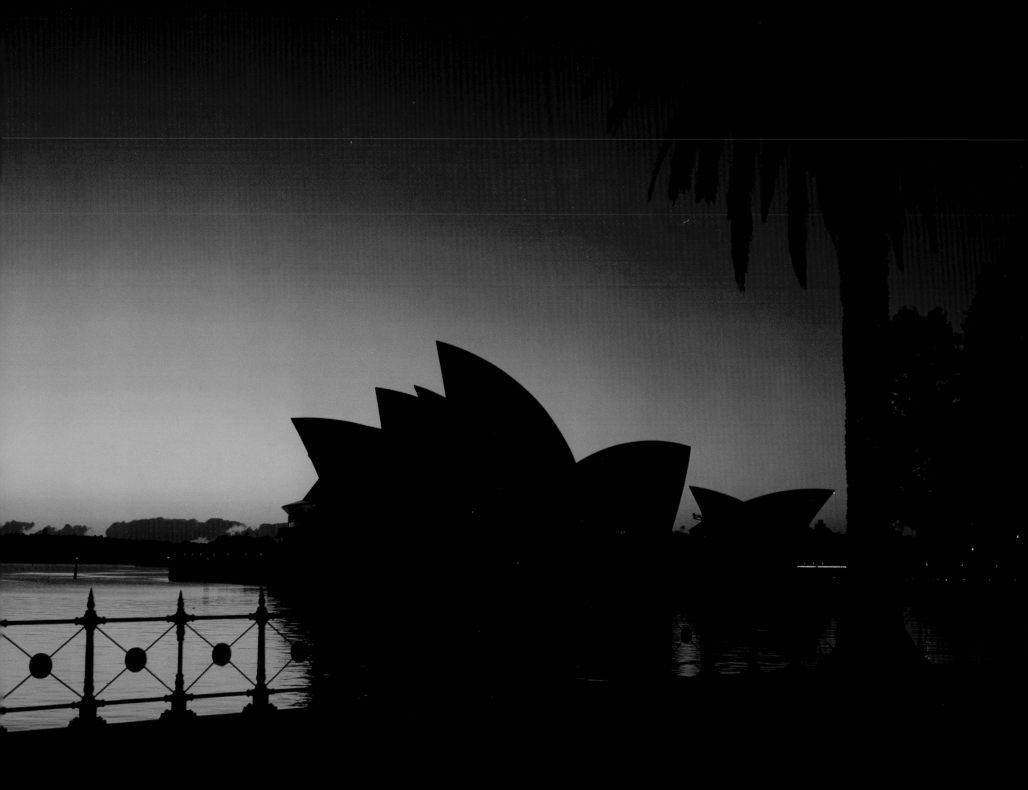

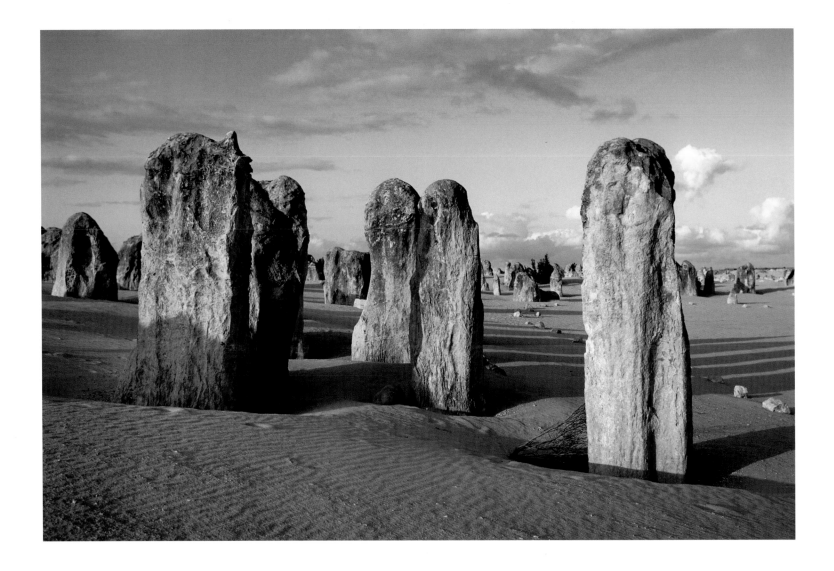

Limestone pillars rise from a sandy plain almost devoid of vegetation
known at the 'Pinnacles' in Nambung National Park.

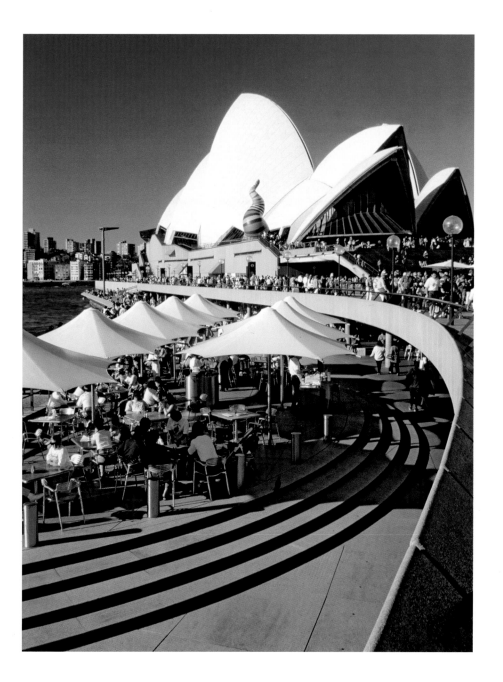

People on the Circular Quay Promenade in Sydney, with the distinctive roofline of the Royal Opera House behind.

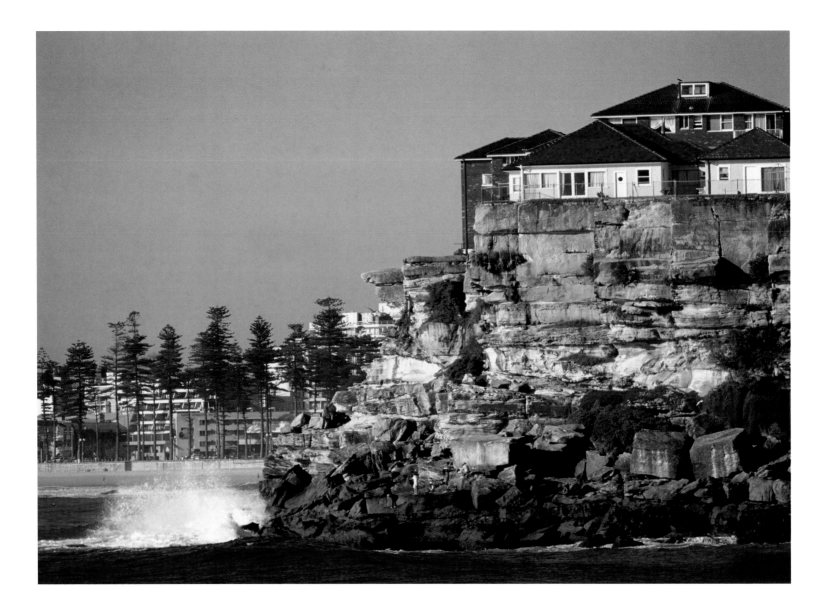

Cliff top houses at Avalon Beach, north of Sydney, have a spectacular view. Manly Beach can be seen in the background.

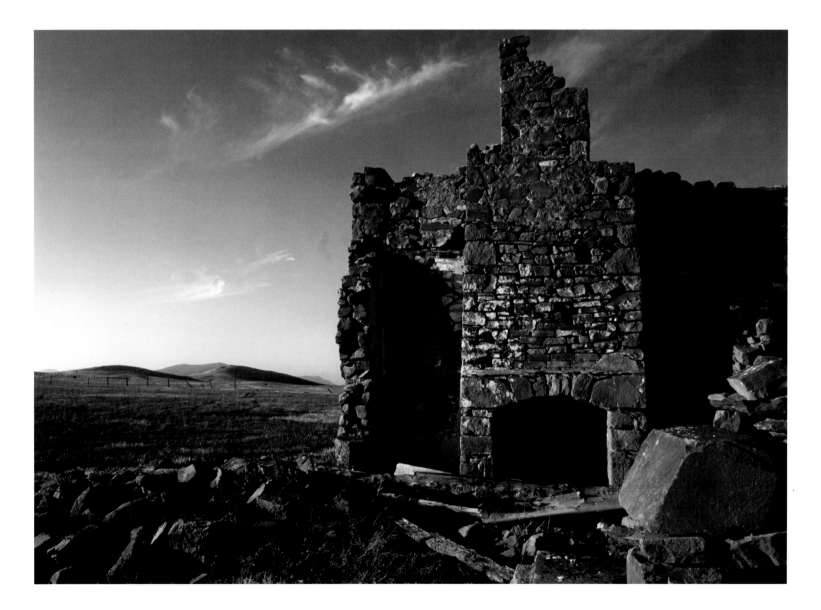

The derelict remains of a building near Hawker in the Flinders Ranges, an area once inhabited by the early European pioneers.
Flinders is South Australia's largest mountain range.

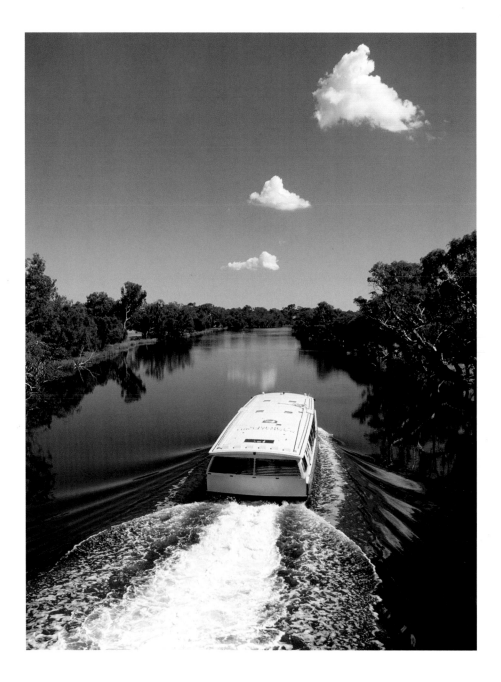

Tour boat cruising on the idyllic Swan River in the
Swan Valley, a wine region near Perth.

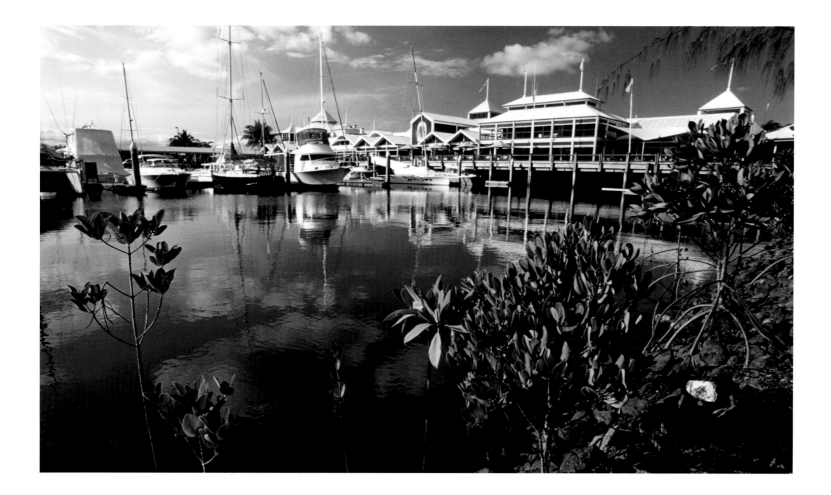

View of the scenic harbour at Port Douglas, North Queensland. The township of Port Douglas grew quickly after the discovery of gold at nearby Hodgkinson River in 1877. Day trips can be made from the resort to the Great Barrier Reef.

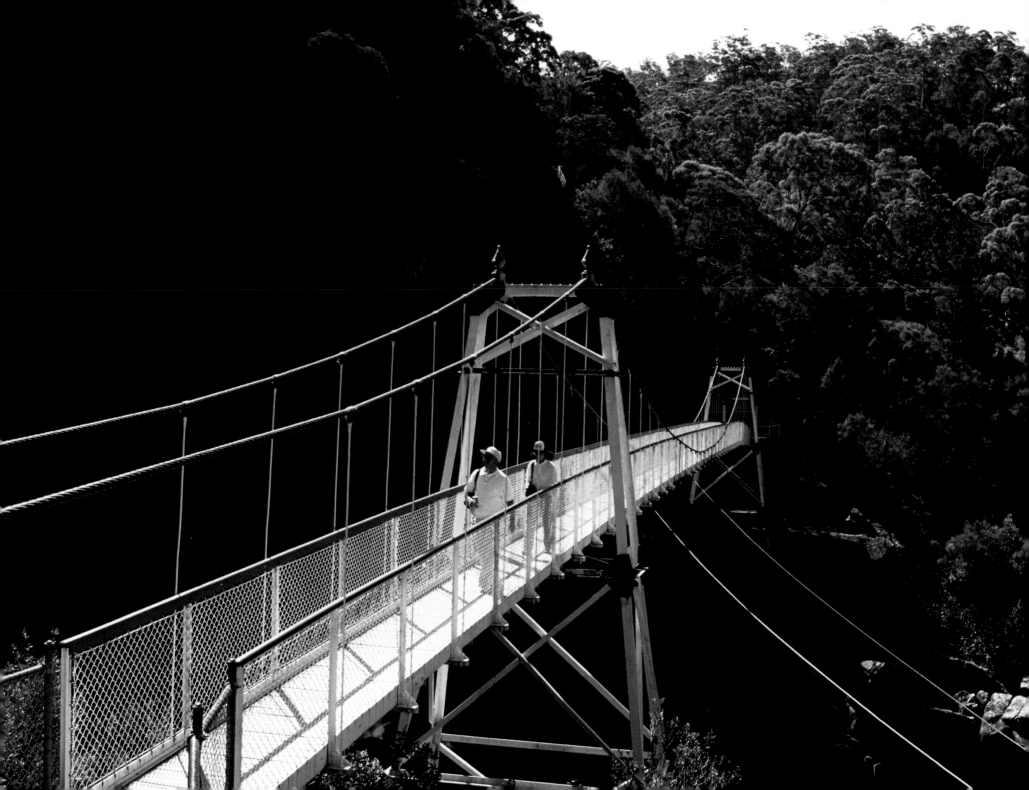

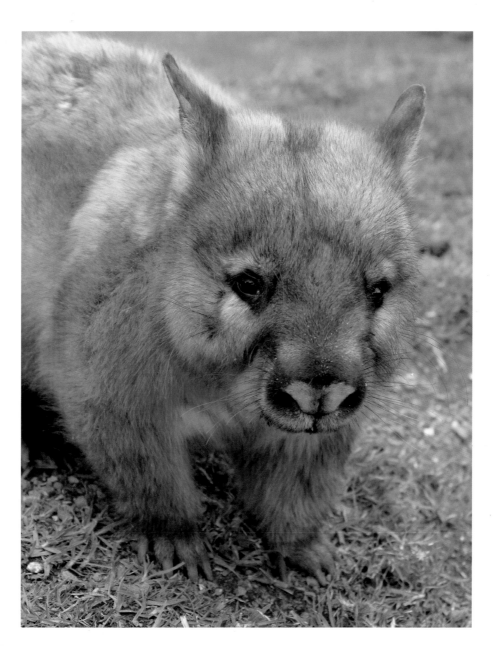

Wombats are found in areas of south-eastern Australia and Tasmania.
Opposite: A footbridge over the Cataract Gorge, close to the centre of Launceston
in Tasmania, where the South Eske River flows into the Tamar.

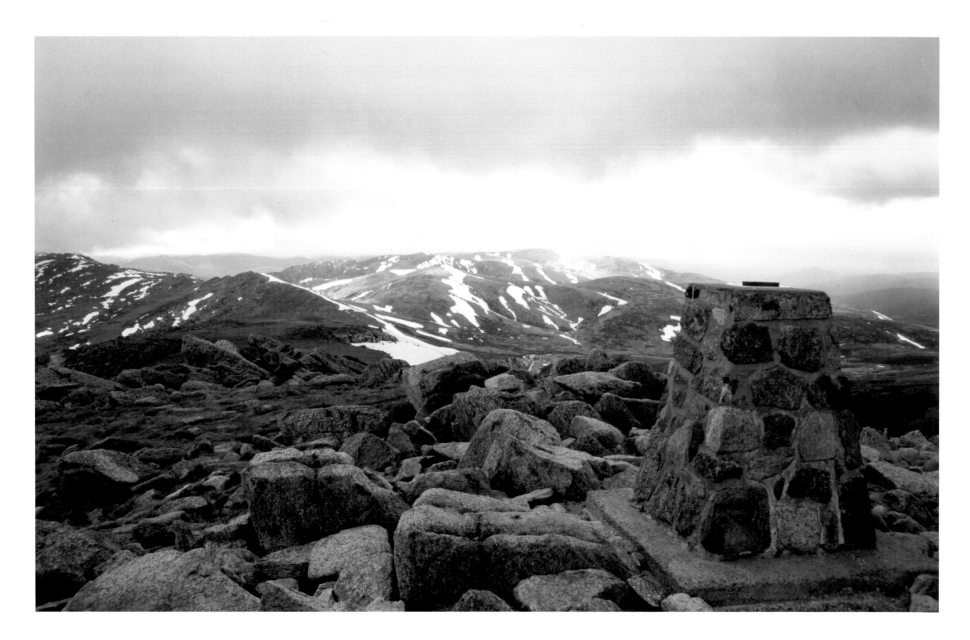

Peaks, glacial lakes and meadows covering 1.5 million acres of the surrounding Mount Kosiuszko in the Snowy Mountains.
It is the highest mountain in Australia at a height of 7,310ft (2,228m) above sea level.

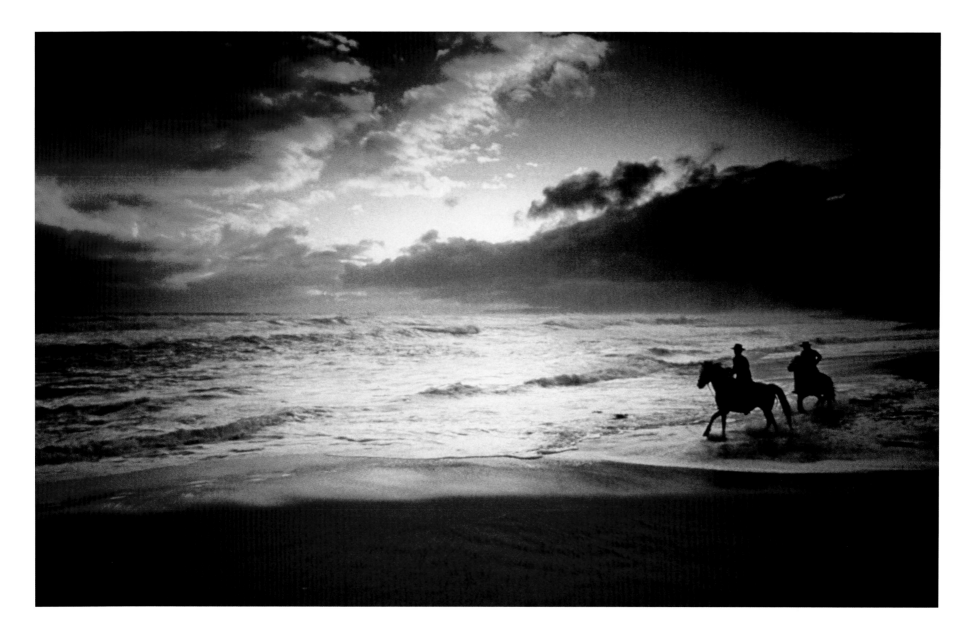

Horse riders at sunset on Cape Otway beach, the southern-most tip of Victoria.

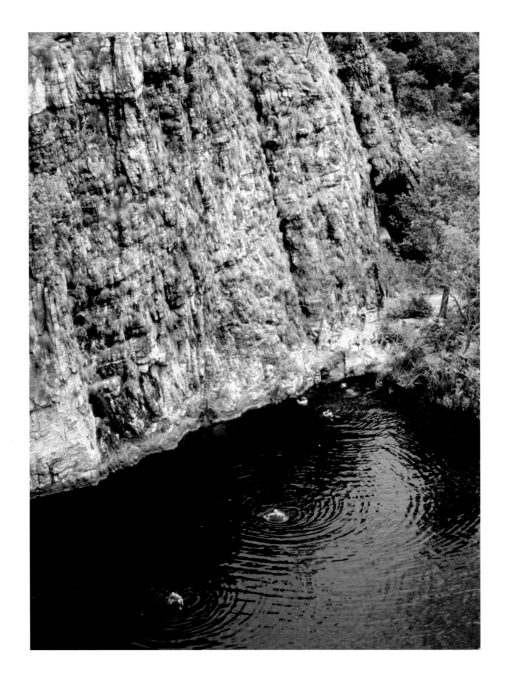

Aerial view of swimmers enjoying a dip in the lower waters
of Maguk in Kakadu National Park.

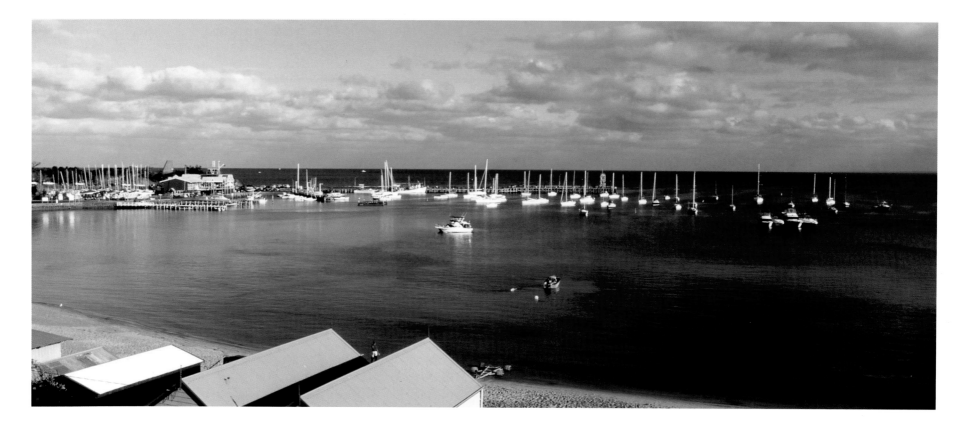

Boat harbour and yacht club at Mornington on the Mornington Peninsula, south east of Melbourne.
This popular resort has a Mediterranean-like climate, which favours local wine production.

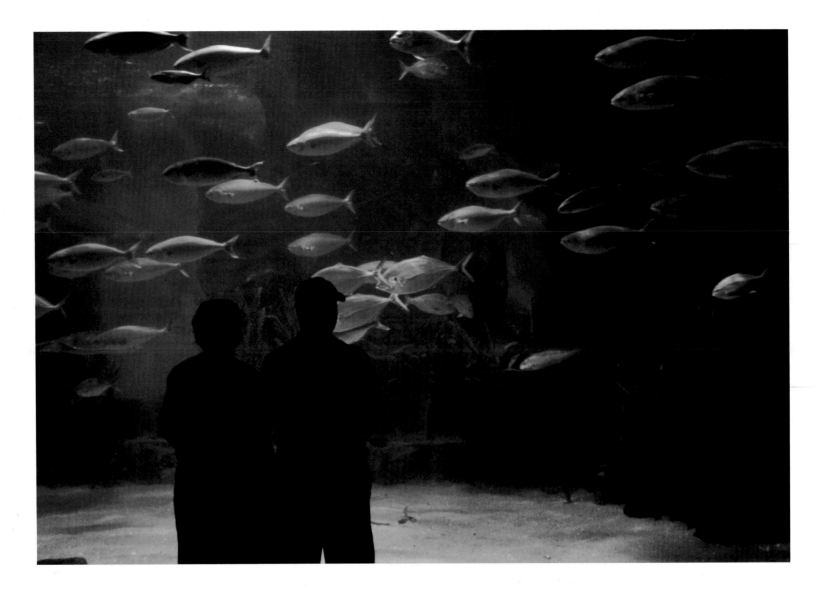

The Fish Bowl at Melbourne's Aquarium on the Yarra River. The oceanarium displays
an array of aquatic life including gummy sharks, stingrays and green turtles.
Opposite: The view from Sydney Harbour Bridge of the Circular Quay with Sydney's high rise buildings beyond.

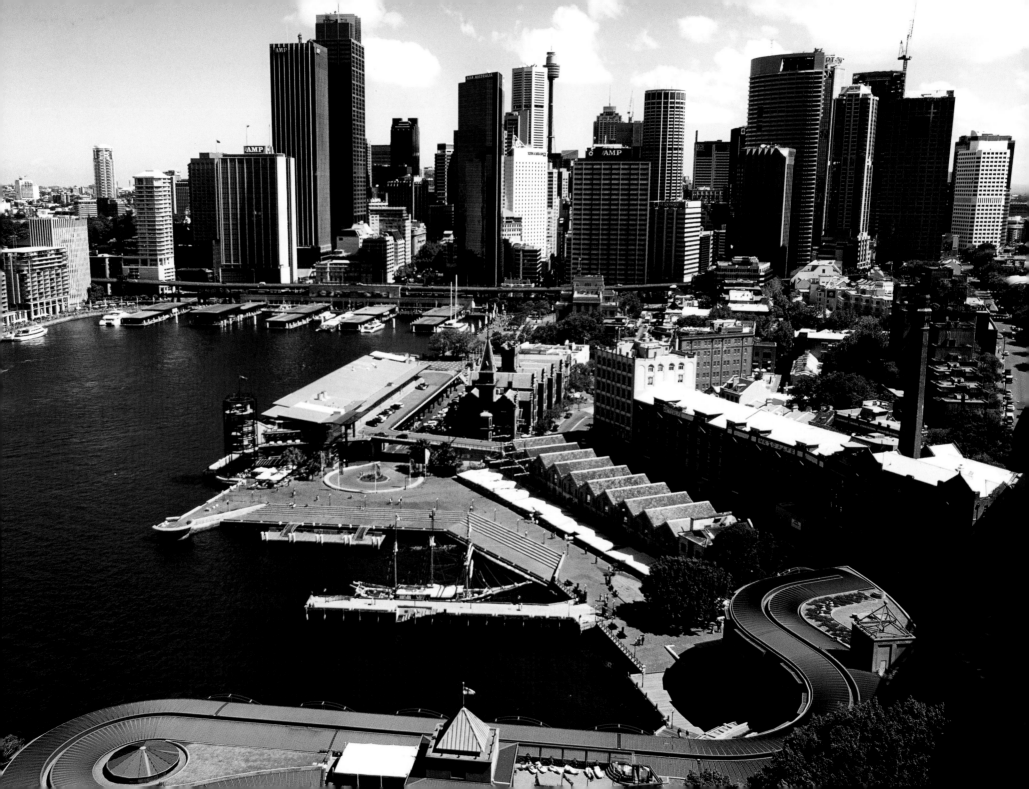

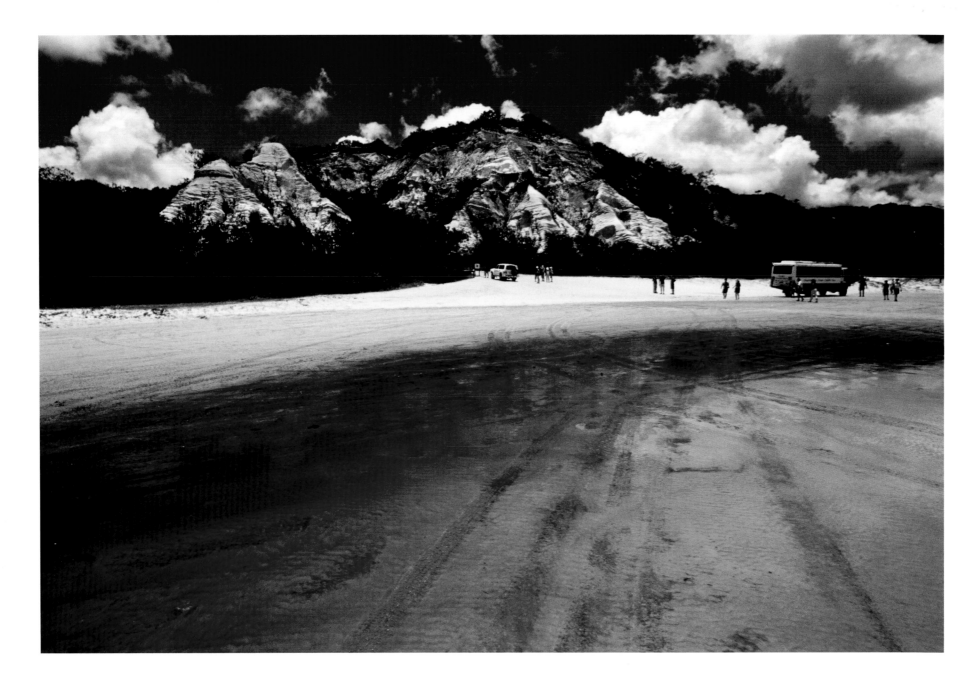

The coloured sands of Fraser Island, the largest sand Island in the world and a World Heritage site. Its freshwater lakes are amongst the earth's cleanest.

Blue Lake, Mount Gambier, on the limestone coast of South Australia.
Its steel-grey water becomes a vibrant turquoise blue in November.

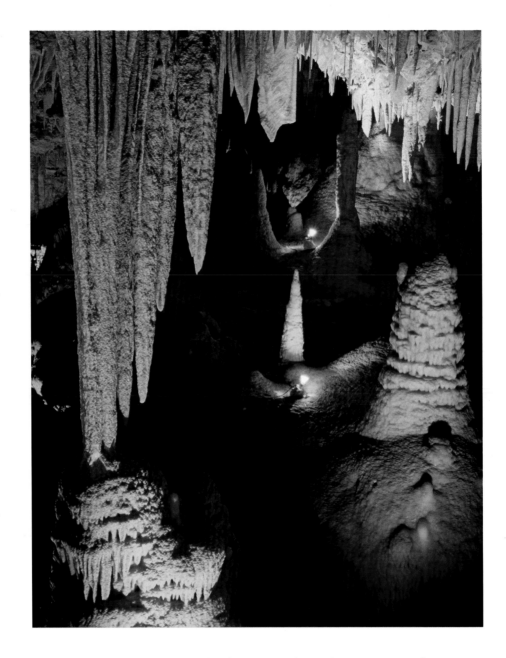

Natural rock formations in the show cave at the Ngilgi Caves, near Yallingup,
Western Australia. The Aboriginal legend about the battle between the good spirit
(Ngilgi) and the evil spirit (Wolgine) gives the site its name.

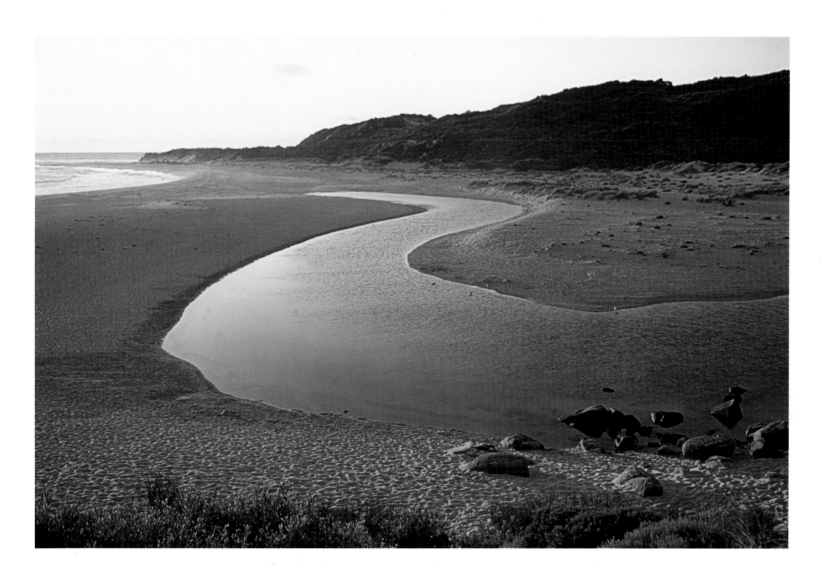

The mouth of the Margaret River, Western Australia. Between May and September the waters off Augusta,
in the south of the region, herald the arrival of migrating whales.

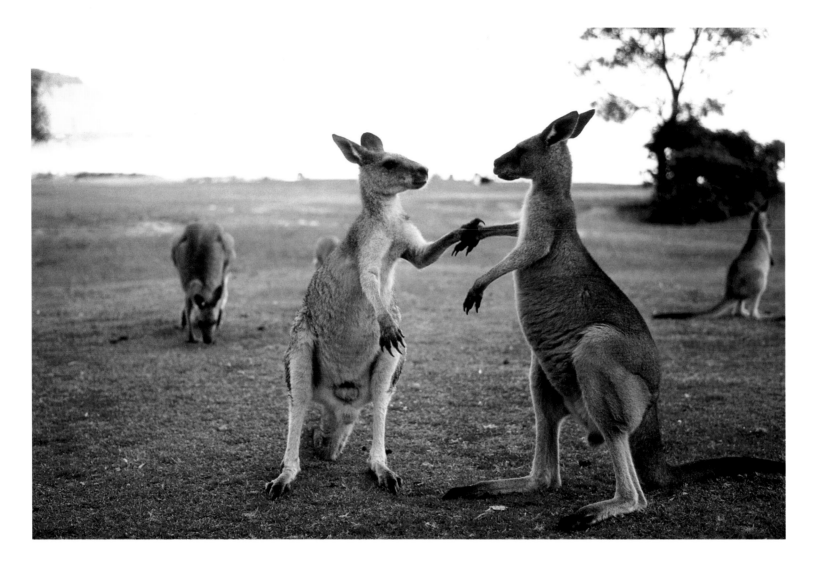

Wild kangaroos at Pebbly Beach near Batemans Bay, New South Wales.

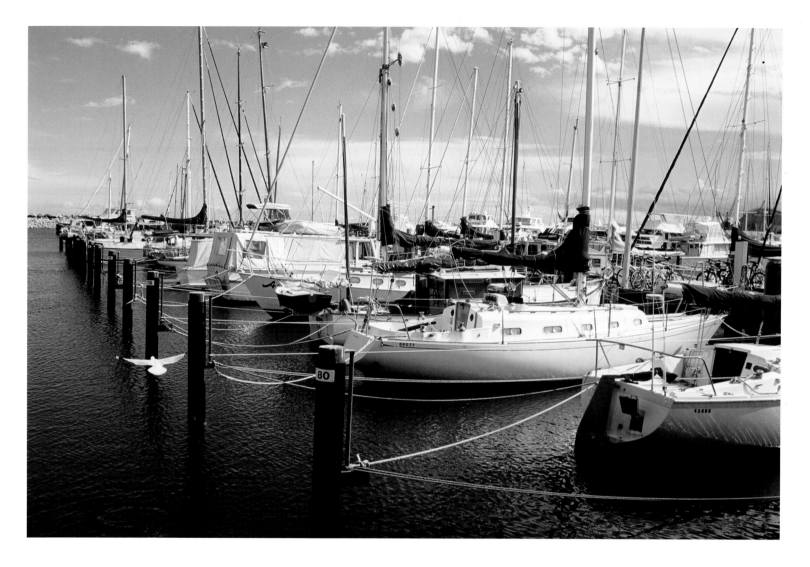

Yachts moored at Success Harbour in Freemantle, Western Australia.
Freemantle is a lively harbour city situated 12.4 miles (20km) from Perth down the Swan River.

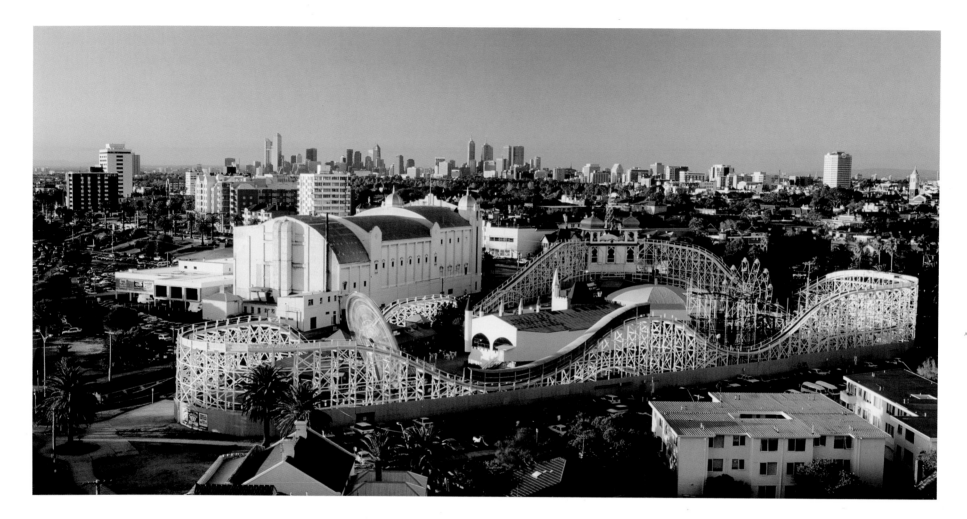

Luna Park funfair in St. Kilda, looking towards the city of Melbourne in the distance.
Opposite: Grape vines growing in the Swan Valley wine growing region.

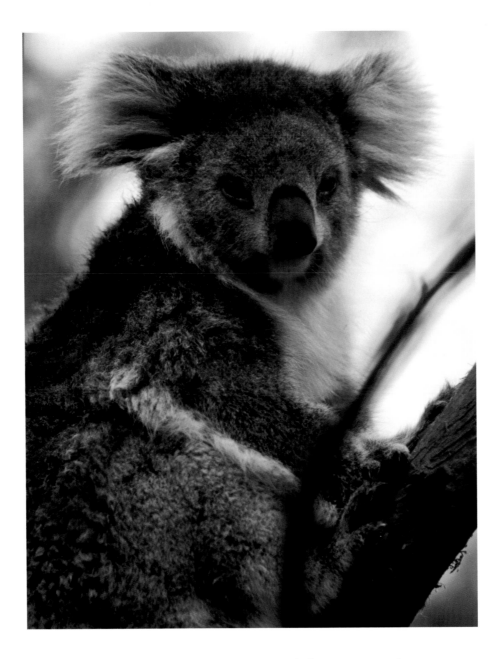

*A koala at the Healesville Sanctuary, which contains more than
200 Australian animal species across 31 hectares of natural bushland.*

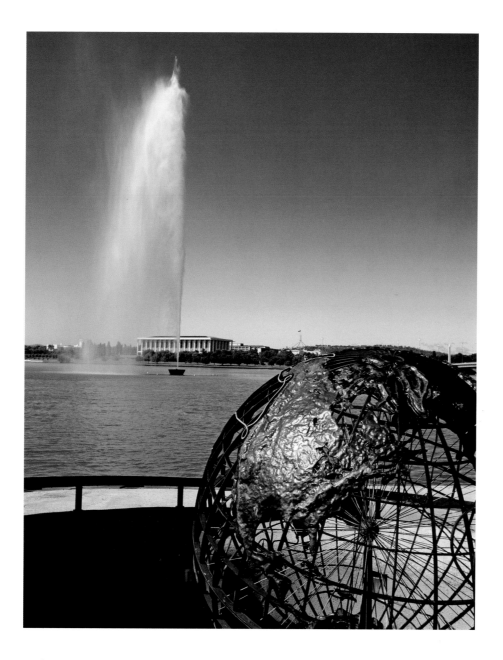

The Captain Cook Memorial Jet on Lake Burley Griffin, Canberra was inaugurated
in 1970 to commemorate the 200th anniversary of Cook's first visit to Australia.
In the foreground is the globe, which charts his voyage.

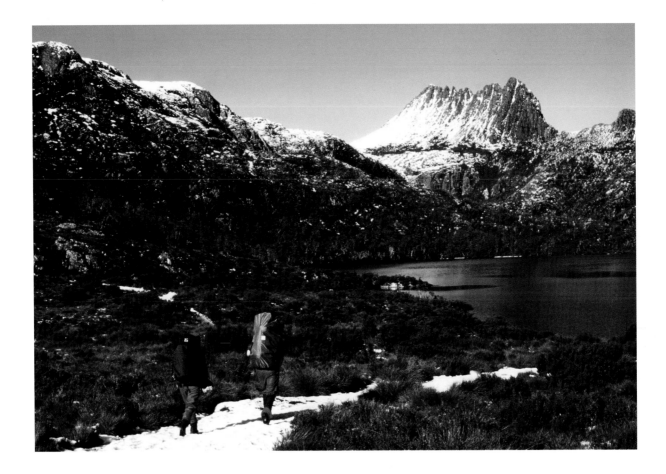

Walkers in the Cradle Mountains, which form the northern end of the Cradle Mountain-Lake St.Clair National Park and which are part of the Tasmanian Wilderness World Heritage area.

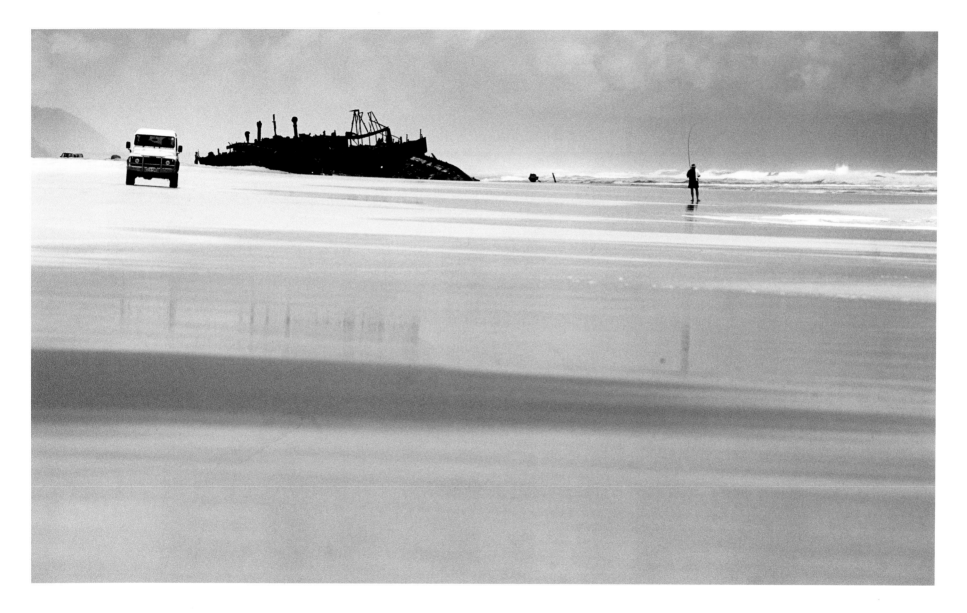

*The SS Maheno, a wreck on the shores of Fraser Island, was driven ashore just
north of Happy Valley during a cyclone in 1935.*

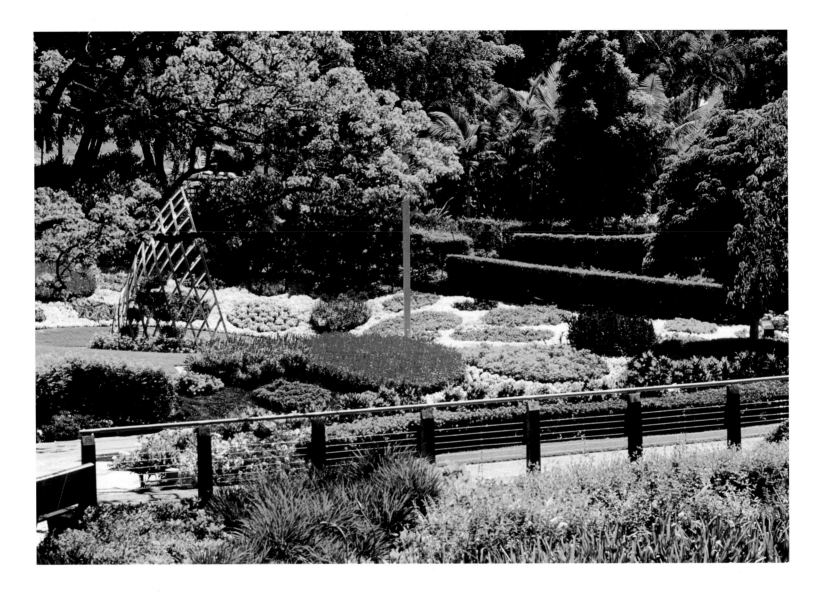

Colourful flower beds at Roma Park Gardens, Brisbane.

Opposite: Uluru at sunset. Its circumference is almost five and a half miles (8km).

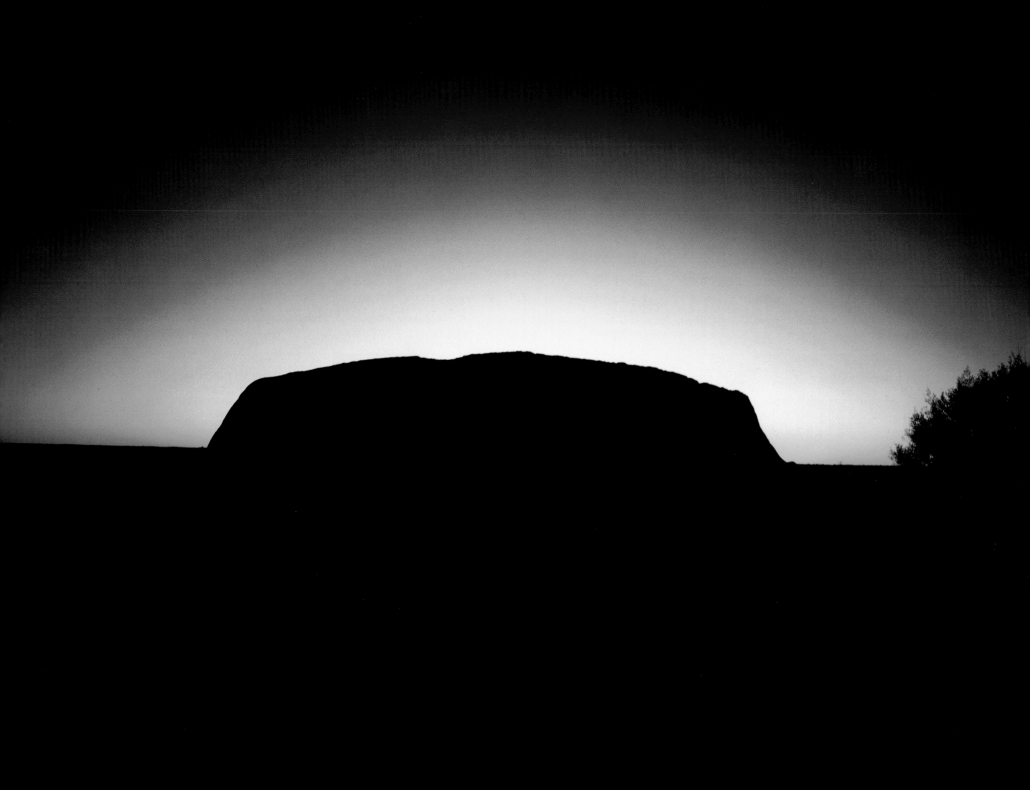

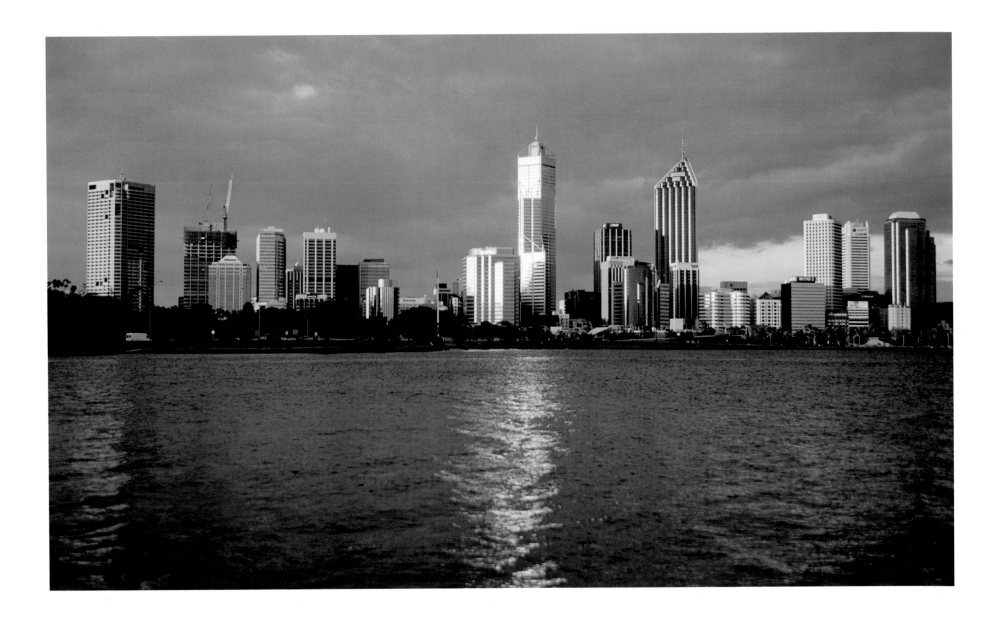

Skyscrapers, illuminated by the evening sunset over Perth City, are seen from across the Swan river.

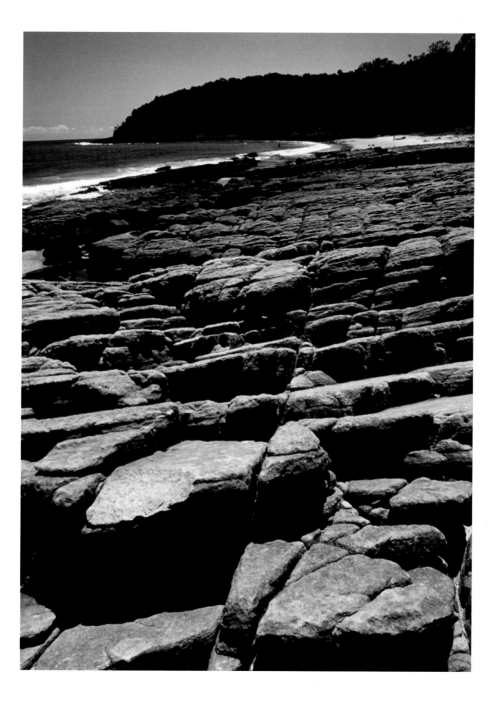

Rocks on the coast at Noosa Heads National Park.

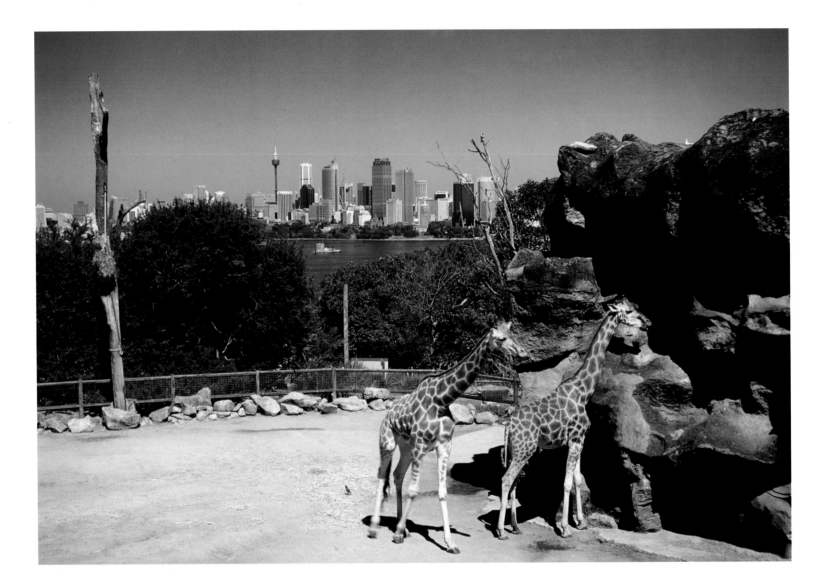

Two giraffes at Taronga Zoo, Bradleys Head. The zoo looks over the harbour and towards the Central Business District of Sydney.

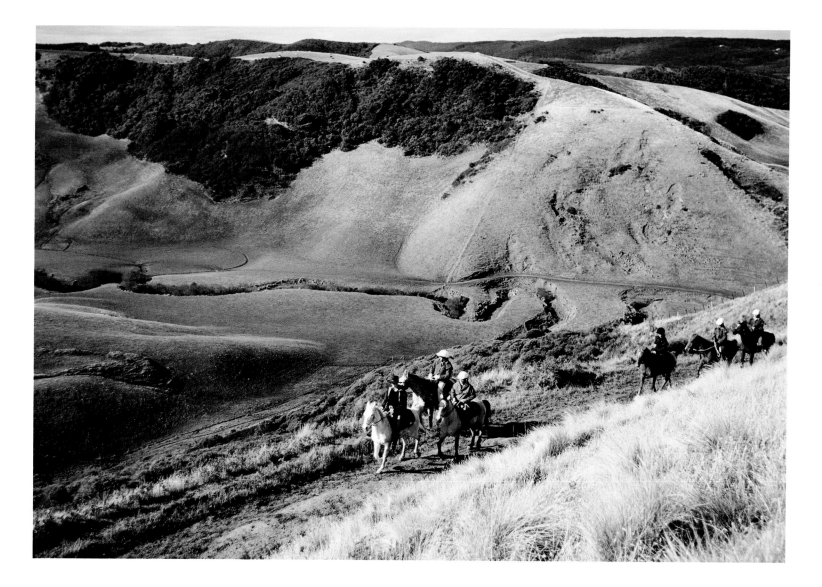

Riders on the horse trail along the Great Ocean Road at Johanna Beach, Victoria.

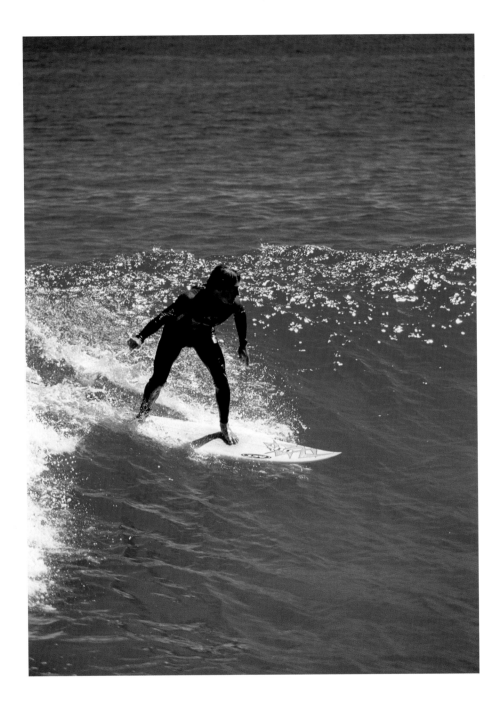

A surfer on a wave at City Beach, Perth.

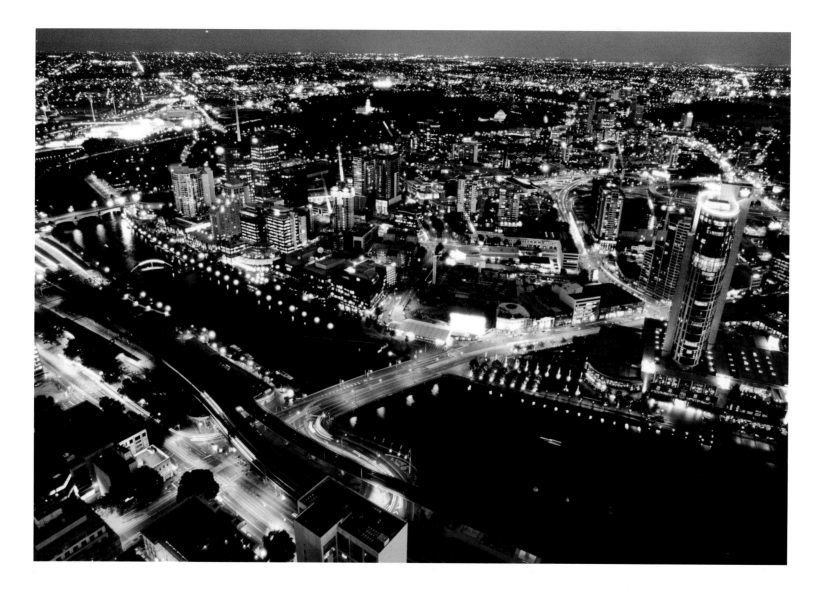

View at night from Melbourne's Rialto Towers observation deck across the Yarra River with the Southgate Complex, and Crown Casino (lit with mauve lights), beyond.

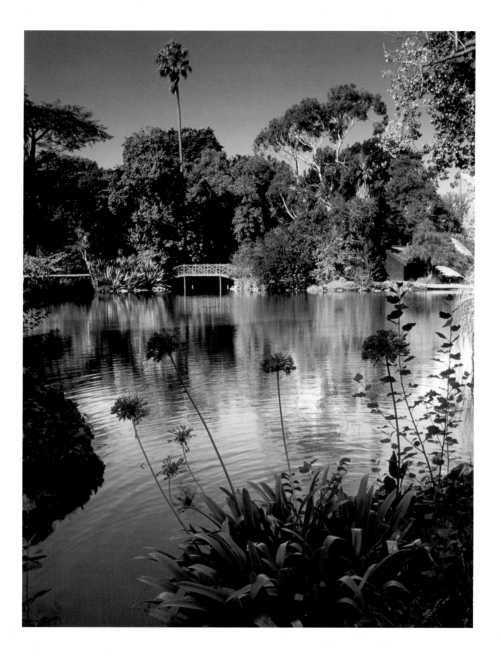

Rippon Lea Estate, a National Trust of Australia property with a National Heritage listed 19th-century mansion house and extensive Victorian gardens.
Opposite: A hibiscus flowering in the tropical climate of Mackay, North Queensland.

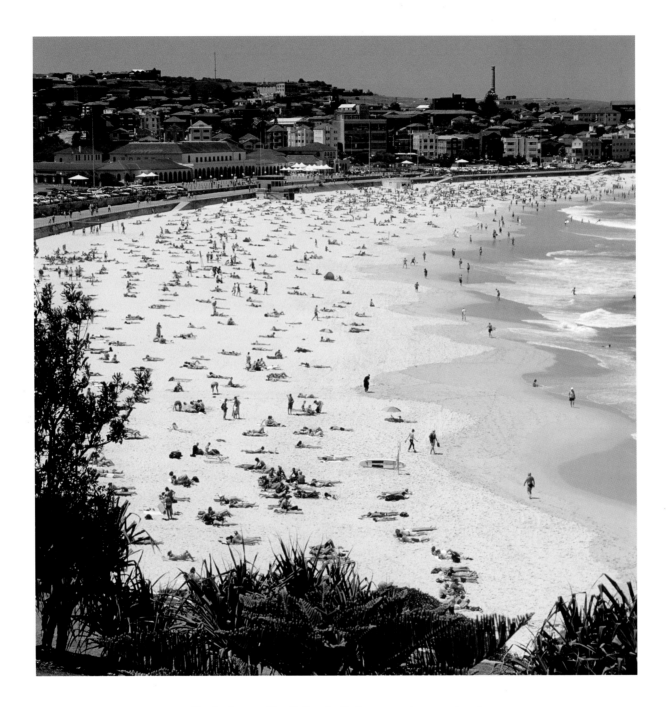

Sunbathers at Bondi Beach, Sydney, on a busy weekend.

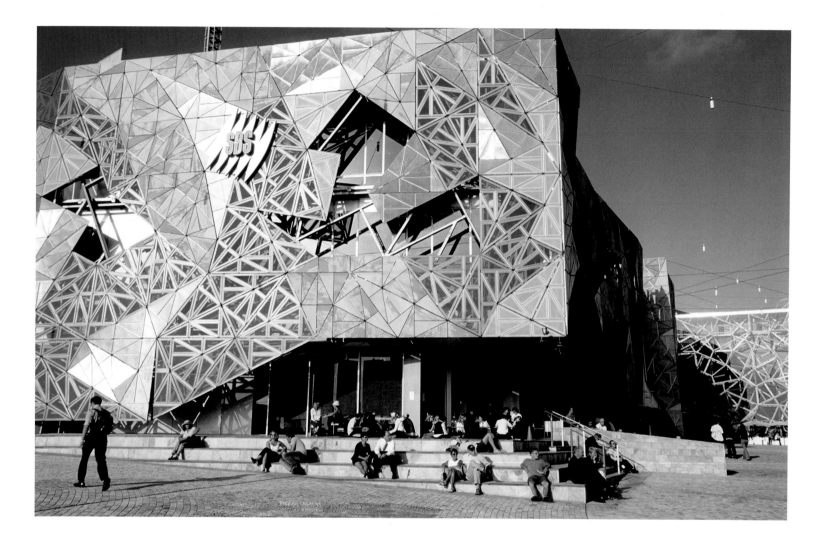

The purpose-built structure of the Australian Centre for the Moving Image at Federation Square, Melbourne.

Oodnadatta Track at William Creek, travels from Port Augusta through the Flinders Ranges
until it joins the Stuart Highway in Southern Australia.

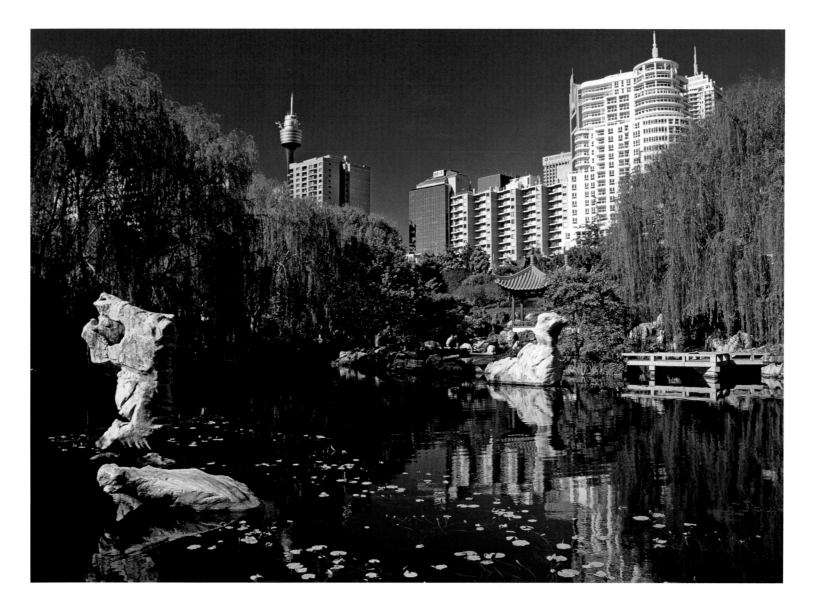

Cantonese-style pavilions and lakes in the Chinese Gardens of Darling Harbour.

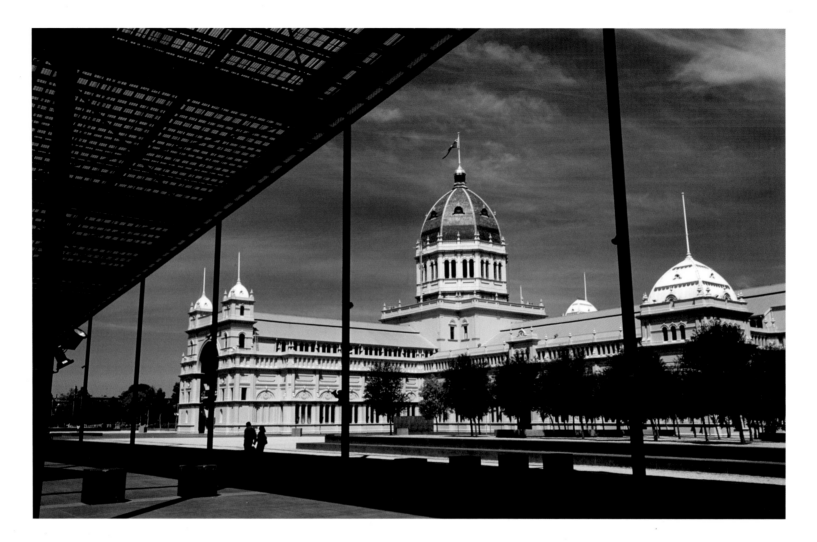

The Royal Exhibition Building, Melbourne, as viewed through the portico of Melbourne Museum.
Opposite: People enjoying the sea and white sands on the Sunshine Coast at Noosa.

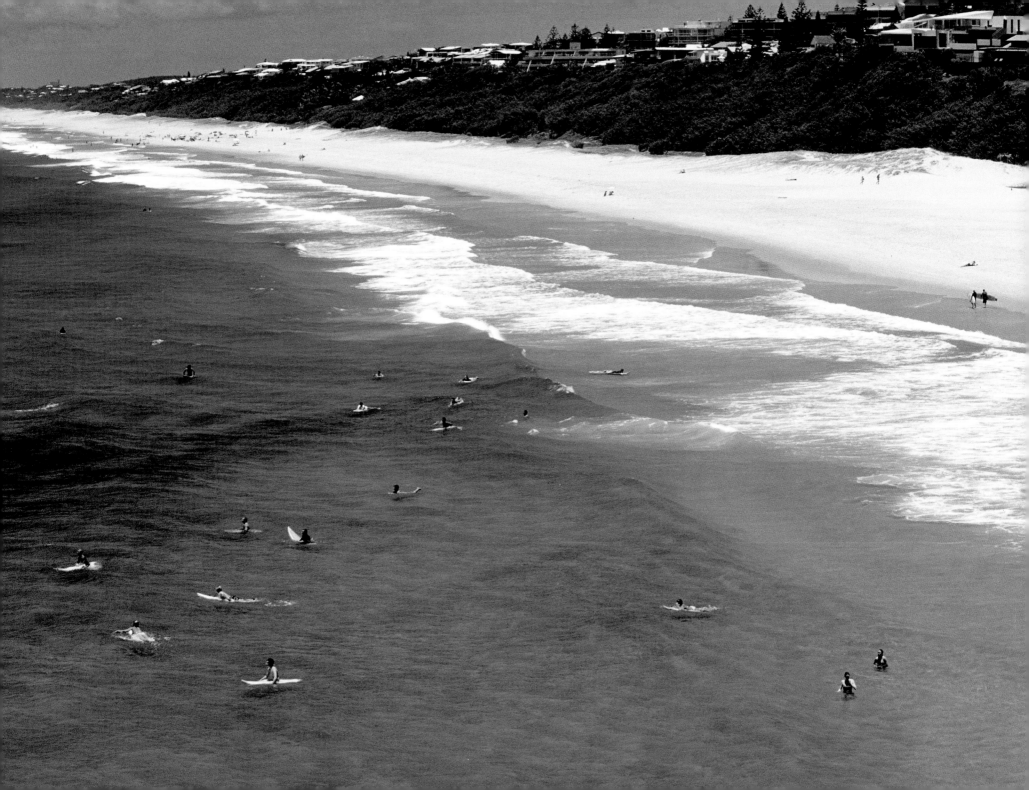

INDEX